POSTCARD HISTORY SERIES

Brockton

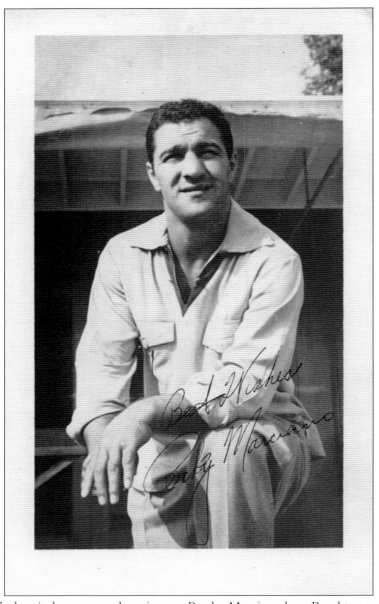

As the city's shoe industry waned, native son Rocky Marciano kept Brockton on the map and a household name when he became boxing's world heavyweight champion on September 23, 1952. Rocky would defend his title six times and retire undefeated with a record of 49–0 on April 27, 1956. This postcard, signed by Rocky, was issued by Grossinger's, a resort in New York's Catskill Mountains where Rocky often trained. (Author's collection.)

ON THE COVER: The postcard on the front cover is from about 1913 and shows the wagon and deliverymen of the Brockton Ice and Coal Company, which continues in business today as the Eastern Ice Company. The postcard on the back cover shows Pres. William Howard Taft in a parade down Centre Street while campaigning in Brockton on October 3, 1912. (Author's collection.)

POSTCARD HISTORY SERIES

Brockton

James E. Benson

ARCADIA
PUBLISHING

Copyright © 2013 by James E. Benson
ISBN 978-1-4671-2007-4

Published by Arcadia Publishing
Charleston, South Carolina

Printed in the United States of America

Library of Congress Control Number: 2013931532

For all general information contact Arcadia Publishing at:
Telephone 843-853-2070
Fax 843-853-0044
E-mail sales@arcadiapublishing.com
For customer service and orders:
Toll-Free 1-888-313-2665

Visit us on the Internet at www.arcadiapublishing.com

This volume is dedicated to the honor of all Brockton business people and their employees past, present, and future for their commitment to the City of Champions.

CONTENTS

Acknowledgments 6

Introduction 7

1. Churches 9

2. Education 23

3. Brockton Fair 31

4. Fire Department 41

5. Public Service 51

6. Recreation 71

7. Industry and Commerce 81

8. Around Town 111

About the Brockton Historical Society 126

About the Metro-South Chamber of Commerce 127

ACKNOWLEDGMENTS

The success of a project is often times determined by the assistance and support that you receive while doing it. This volume would not have been possible without the help of the following: the Brockton Historical Society and Fire Museum, the Metro-South Chamber of Commerce, First Evangelical Lutheran Church and the Reverend Mark T. Peterson, retired fire chief Kenneth Galligan, retired fire lieutenant George Churchill, fire lieutenant Edward Williams, Christopher Donovan, Christopher Cooney, Alison VanDam, Carl Landerholm, Ronald B. Newman Sr., Christine Newman, Lloyd and Wilette Thompson, Ron Bethoney, and Frederick Lincoln.

A special thank-you goes to Caitrin Cunningham and the entire staff of Arcadia Publishing for making this, my sixth venture with them, an enjoyable experience.

Finally, no project can be accomplished without the support of family, and to that end, I thank them all for their encouragement and support, with a special thank-you to my feline editor, Smokey.

Unless otherwise noted, the postcards and images in this volume appear courtesy of the author's personal collection.

INTRODUCTION

Brockton, Massachusetts, has a deep and storied past, from its days as a part of Old Bridgewater to its colonial days as a farming community and from its beginnings 200 years ago as an industrial center of the shoe industry to being known the world over as Shoe City, USA. Brockton shoe manufacturers sold their product on six of the world's seven continents. Brockton manufacturers travelled and opened sales outlets in distant lands; the manufacturers of this city were progressive, industrious, and inventive. Out of Brockton came hundreds if not thousands of patents, new ideas in workplace safety, and employee benefits; Brockton businessmen were not afraid to invest their capital in the city and in their businesses. Most businessmen of the city lived in the city, went to church in the city, and spent their fortunes in the city. Brockton businesses, as you will read in these pages, began using postcards in the 1890s. Postcards were designed to be an inexpensive method of communication in the days before the electronic exchange of information. When reading the addresses on some of these cards, one wonders in amazement how they got to where they were destined to go—for example, how did a card simply addressed to Mrs. Albin Johnson, Campello, Massachusetts, ever get to her? As a result of our need for instant communications and want for information, the postcard in nearly every form, with the possible exception of junk mail, is fast becoming obsolete. Such was not the case a century or more ago when businesses and industries sought quick and effortless ways to communicate with customers, and as travel by automobile grew at the beginning of the 20th century, the real-photo postcard industry took off. People travelling to all parts of the country and globe were quick to purchase postcards to mail to family and friends to show off where they had been and the great things they had seen. Local photographers began to use local buildings, events, and scenes to increase their business. At some point in their business careers, Brockton photographers were no different, and in this volume, the reader will find images by Burrell, Judson, and Glasier and some published by larger firms, such as Underwood. Brockton business owners realized that the postcard was a great way to meet new customers, and so, the "junk mail" boom was well on its way. Local chambers of commerce and city governments were also quick to add postcards to their marketing plans and packages.

It is said that 1907 to 1915 was the golden age of the postcard; many people bought and saved them, amassing large collections. The US Post Office estimated that a billion or more penny postcards were being mailed annually at that time. Many of the cards in this book are from that golden age and are images of what Brockton was like a century or more ago.

Brockton had much to be proud of and much to show off in those early years. Shoe manufacturers, such as Douglas, Keith, and others, would have their factories photographed and postcards made, sending them around the world. Brockton's city hall was photographed from almost every angle

possible for postcards. D.W. Field Park appeared a virtual Eden within an industrial cocoon. The postcards in this volume give the reader a view of a growing and changing city—a city of progress. These images portray stately buildings and busy streets where trolleys almost seem to come to life as you look at the card.

These postcards will be a nostalgic trip down memory lane to some, and to others, they will inform people of what Brockton was. The images will also show some of what Brockton lost in her many 19th-century buildings, which were well constructed and well maintained but lost to urban renewal. Some when looking at these images will laugh at things that look plain and simple, at things as ugly as a 1930s bus, or as beautiful as an 1880s horse-drawn trolley. Others will look in amazement at the big-box stores of a century ago when department stores were something new and went so far as to advertise, as in one case, "nineteen stores under one roof."

The images contained herein show Brockton as a city of progress, of new thoughts and ideas, and of a city transforming before your eyes. As this book appears on seller's shelves, the Metro-South Chamber of Commerce, today's continuation of the Brockton Board of Trade and the Brockton Chamber of Commerce, will celebrate its 100th anniversary. In 1913, it was relatively simple to be the mouthpiece for promoting the city and its industrial base as it was pretty much a one-industry town with all of the related industry being attracted to their customer base. Today, there is no single industry that dominates the stage, and there are no postcards to pass onto future generations. We salute the Metro-South Chamber of Commerce on its centennial, and we salute those businesses, whether they are still here or if they have moved on, portrayed in these pages—for they built the city.

One

CHURCHES

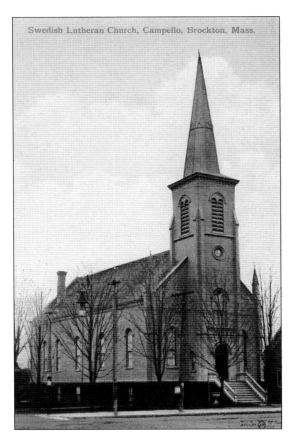

Swedish Lutheran Church, Campello, Brockton, Mass.

The religious life of Brockton was a vital aspect of city life, and congregations of all faiths and denominations dotted the city landscape. As a city of immigrants, many ethnic groups brought their faith with them to their adopted home. Swedish immigrants first arrived in Brockton in 1854 and by 1867 had formed the First Swedish Evangelical Lutheran Church. In 1870, the congregation dedicated its first house of worship, pictured here, at the corner of Main and East Nilsson Streets.

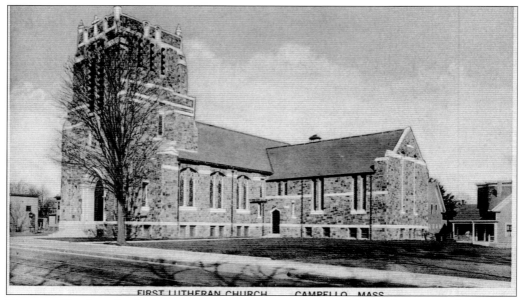

Drawn to Brockton by the burgeoning shoe industry, the Swedish immigrant population grew rapidly, and by the outbreak of World War I, the congregation of the First Swedish Evangelical Lutheran Church had outgrown its wood-frame building; in 1922, this granite edifice was erected on the same site. As the congregation became more American born, the name Swedish was dropped from the name. The church continues today as a strong anchor in the Campello community.

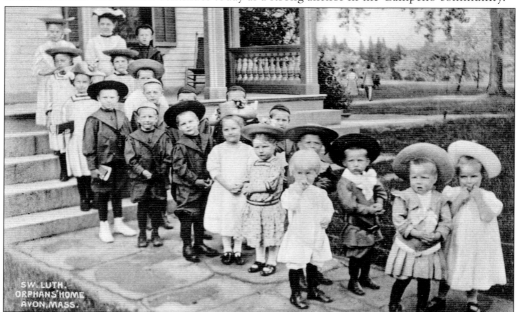

In 1904, J. Alfred Anderson, pastor of the First Swedish Lutheran Church, gathered support from other Swedish Lutheran congregations in the region to establish a Swedish Lutheran Orphan's Home in Avon on the estate of Sara Blanchard. For nearly six decades, this home would care for orphans from the Swedish community as well as provide temporary care for many children in time of family need.

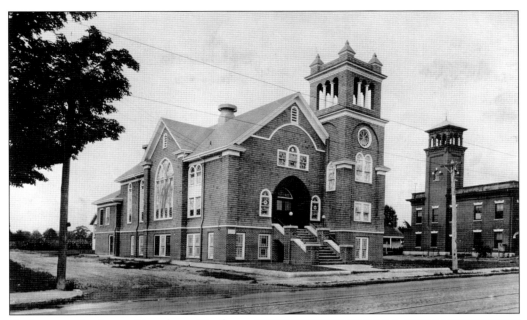

Gethsemane Lutheran Church on North Main Street in Montello was officially organized on July 16, 1895. The fledgling congregation's first home was in a small church built on Ames Street for a mere $800. The tower in the background, Italianate in design, is the hose and bell tower of fire station No. 3. (Courtesy of Ronald B. Newman Sr.)

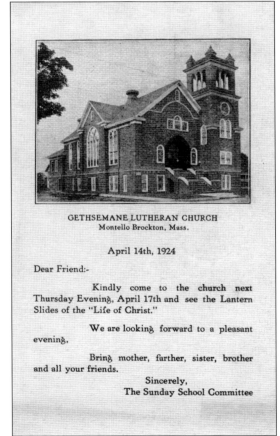

This postcard, advertising a lantern slide show in April 1924 depicts the edifice as dedicated in 1923. Lantern slides were glass slides, most about three inches square, that were projected on a screen. In 1911, the congregation purchased the site and constructed a basement church, delineated by the band of molding just above the lower windows. The superstructure was added in 1923.

11

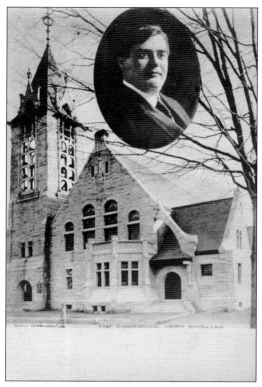

This handsome granite edifice was the home to the First Parish Congregational Church on Pleasant Street. This building was erected following the loss of the congregation's large wooden church on January 24, 1894. On February 19, 1965, this church was also consumed by fire. Two firefighters from Hanson were killed responding to the fire when their engine collided with an oil truck in Whitman. The building was razed, and a brick edifice, which is today's Mount Moriah Baptist Church, was constructed on the site. In 1980, First Parish was a partner in the consolidation of several congregations, ending in present-day Christ Congregational Church. The inset in the image at left is of Rev. Alan Bedford Hudson, who was called to serve as pastor following the loss of the wood-frame church. Ministering to a scattered flock, Hudson brought the remnants of the congregation back together to celebrate their new building and ministered among them for 19 years.

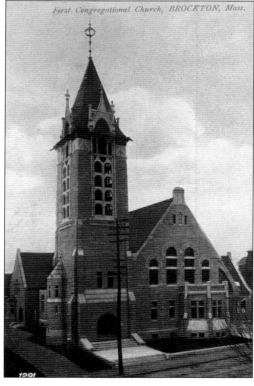

First Congregational Church, BROCKTON, Mass.

The Porter Evangelical Church came into being on March 20, 1850, when a group of dissidents broke away from the First Parish Church. The goal of those who formed Porter Evangelical Church was to return to preaching orthodox Congregational doctrine. This new church was named in honor of John Porter, the first clergyman to serve First Parish Church in 1740. The new society purchased a lot of land north of First Parish and erected their first structure, which was designed by the architectural firm Melvin and Young of Boston and dedicated on January 9, 1851. In 1883, the church was enlarged under the auspices of Boston architect T.M. Silloway. The original spire of 175 feet was replaced with that shown in the image at right and subsequently with that in the image below. Porter Evangelical Congregational Church joined the coalition that formed Christ Congregational Church in 1980.

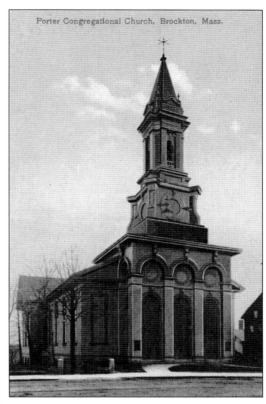

Porter Congregational Church, Brockton, Mass.

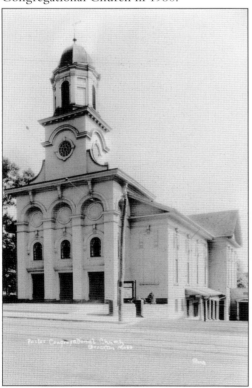

Porter Congregational Church
Brockton, Mass.

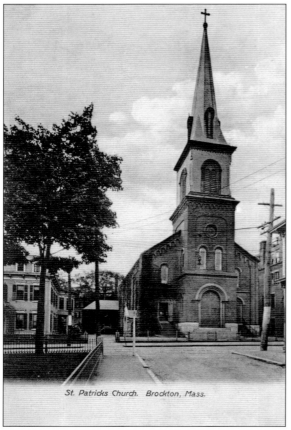

St. Patricks Church. Brockton, Mass.

As the number of Irish immigrants to the city grew, the need for a Catholic church grew as well. In 1856, Rev. Thomas B. McNulty was assigned to Brockton and immediately began the push for a church. After purchasing a parcel of land on Main Street near Wales Avenue, a beautiful brick-and-granite structure with a spire soaring 180 feet above Main Street, was constructed. This church, 110 feet long and 50 feet wide, had a seating capacity of 700. This church incorporated the Romanesque style of architecture of the time, along with elements seen in the colonial churches of an earlier time. In 1912, the need for a larger church was realized, and the construction of a new edifice and rectory started next to the historic Gardner Kingman house and across from the new Brockton Public Library building, which was erected in the same year.

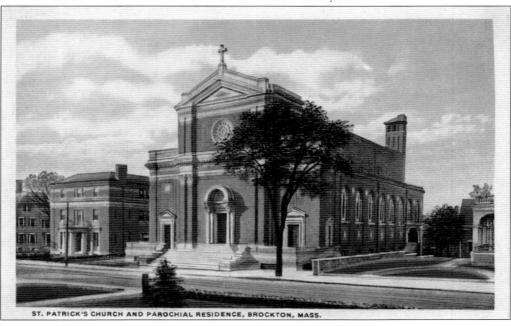

ST. PATRICK'S CHURCH AND PAROCHIAL RESIDENCE, BROCKTON, MASS.

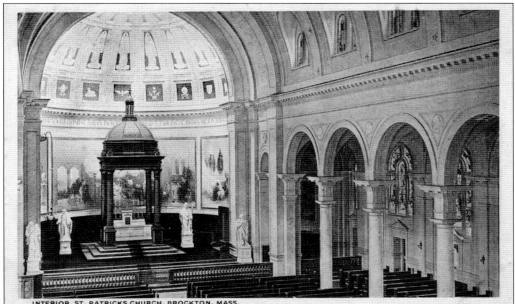

INTERIOR, ST. PATRICKS CHURCH, BROCKTON, MASS.

The interior of the new St. Patrick's Roman Catholic Church was befitting of a cathedral with its columned aisles, high clerestory windows and elaborate paintings behind the chancel, and a domed apse. The church featured a massive ciborium or baldachin over its altar, an architectural element often reserved for cathedrals and basilicas. Perhaps, the most famous in the world is that designed by Bernini for the high altar at Rome's St. Peter's Basilica.

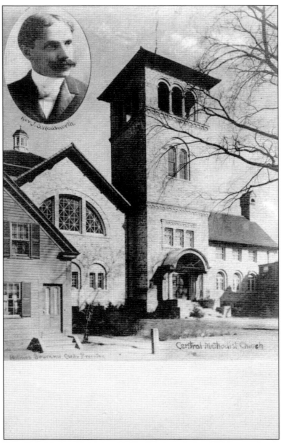

The Central United Methodist Church was gathered on March 2, 1842, with about 30 members. It is said that it was formed so that residents of Center Village did not have to travel to the west church, Pearl Street Methodist, for services. After occupying several locations, the congregation erected a handsome structure on Church Street, and in 1900, the church pictured here was constructed. It was designed by John Williams Beal.

15

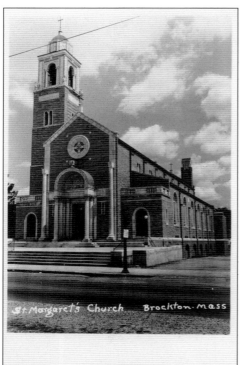

St. Margaret's Church Brockton. Mass

A new parish for Brockton was announced on July 20, 1902; it was to be dedicated to St. Margaret of Scotland. Fr. John F. Keleher, pastor of the parish, encouraged the architects to diverge as much as possible from the standard New England ecclesiastical design, and its final style was in the Italian Byzantine. The basement church was dedicated in 1903 and the superstructure in 1928. Closed in 2003, the building is today home to the Brockton Haitians Church. (Courtesy of the Brockton Historical Society Fire Museum.)

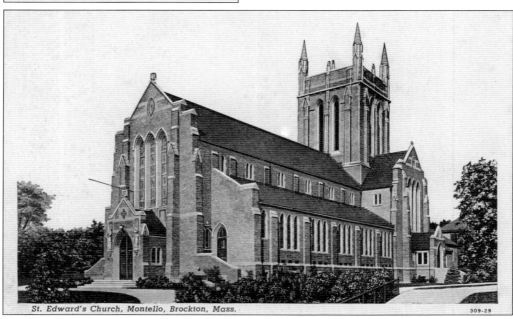

St. Edward's Church, Montello, Brockton, Mass. 309-29

Rising above the skyline of the Montello section of Brockton is the Gothic Revival structure of St. Edward's Roman Catholic Church. Today, known as the parish of St. Edith Stein, this building was designed by Maginnis and Walsh of Boston, architects who have to their credit the National Shrine of the Immaculate Conception in Washington, DC, as well as much of the campus of Boston College and the Massachusetts Veterans War Memorial Tower atop Mount Greylock.

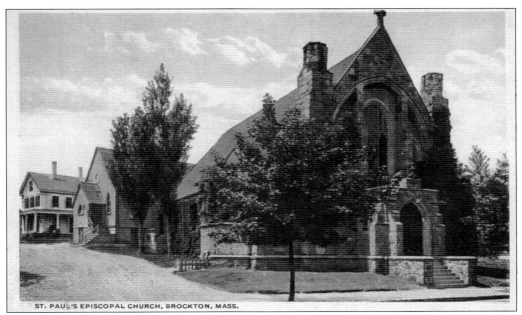

ST. PAUL'S EPISCOPAL CHURCH, BROCKTON, MASS.

It is recorded that the first services of the Episcopal church were held in Brockton in 1871, and St. Paul's Episcopal Society was formed, opening a small chapel on Pleasant Street, in 1877. It was enlarged and later moved. The building pictured here, designed by the famous church architect Ralph Adams Cram, replaced the original wood-frame Norman-Gothic structure in 1893. St. Paul's closed its doors in 2010.

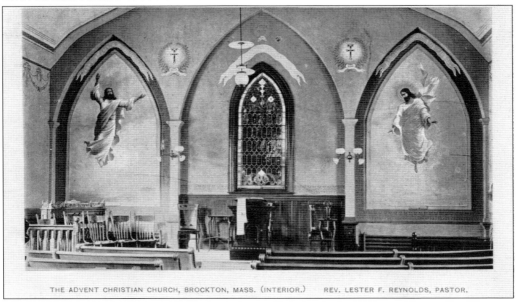

THE ADVENT CHRISTIAN CHURCH, BROCKTON, MASS. (INTERIOR.) REV. LESTER F. REYNOLDS, PASTOR.

Rev. William O. Hale of Worcester, Massachusetts, organized the Advent Christian Church around January 1, 1888. The first meetings were held in the Enterprise Building and later Joslyn Hall on Centre Street. The congregation settled its first permanent pastor in 1891. This image depicts the interior of their building located at the corner of Waverly and Turner Streets. (Courtesy of the Metro-South Chamber of Commerce.)

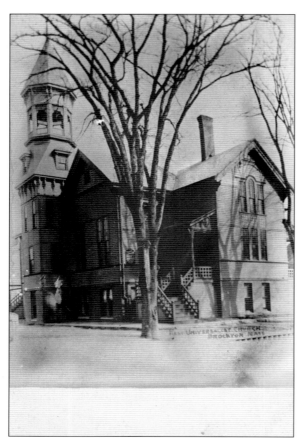

The beginnings of the First Universalist Church can be traced to 1855. In 1863, this group built its first edifice on Elm Street and dedicated the building pictured here on May 4, 1888. Located on Cottage Street, this church, with its distinctive octagonal bell tower, was designed by local architect Waldo V. Howard and counted among its members shoe barons William L. Douglas and Moses Packard.

Constructed at the intersection of Warren Avenue and West Elm Street in 1910, the First Baptist Church was designed by Arthur Eaton Hill and is a mix of Tudor and Gothic architectural styles. This building is very similar in style to other churches designed by Hill. The roots of this congregation date to 1850, and today, this building is home to the Brockton Assembly of God.

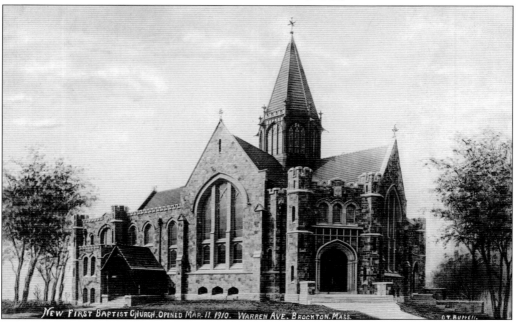

NEW FIRST BAPTIST CHURCH. OPENED MAR. 11. 1910. WARREN AVE. BROCKTON. MASS.

In 1878, when the First Swedish Lutheran Church was without a pastor, a layman by the name of C.W. Holmes began to exhort his fellow Swedes to follow Congregationalist doctrine and welcomed travelling preachers to visit with them. In 1880, this group constructed its first building and, in 1887, erected a new structure at the corner of Nilsson and Laureston Streets. This immigrant congregation received substantial help from the South Congregational Church and shoe manufacturer George E. Keith.

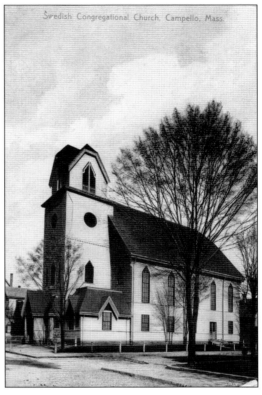

Swedish Congregational Church, Campello, Mass.

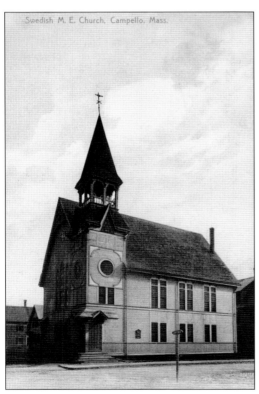

Swedish M. E. Church, Campello, Mass.

In the fall of 1890, Swedish immigrants seeking something different than what the Lutherans or Congregationalists could offer organized the Swedish Emanuel Methodist Episcopal Church. Meeting in the Franklin Building at Main Street and Perkins Avenue, the group soon erected this wood-frame church on Nilsson Street in between the First Swedish Lutheran and Swedish Congregational Churches; a short distance to the north was the Swedish Baptist church.

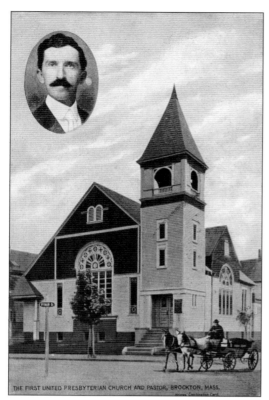

THE FIRST UNITED PRESBYTERIAN CHURCH AND PASTOR, BROCKTON, MASS.

The First United Presbyterian Church was organized in 1899, and in 1902, members erected this house of worship at the corner of Wyman and Turner Streets. The inset is a portrait of Rev. Thomas F.B. Smith, who was installed at pastor in December 1905. Today, the building is home to Eglesia De Jesucristo El Buen Samaritano, the Church of Jesus the Good Samaritan.

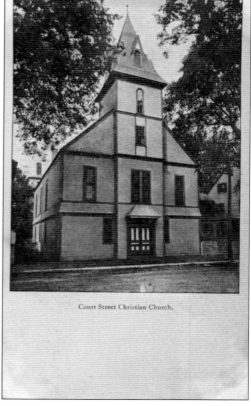

Court Street Christian Church.

Little is known about the Court Street Christian Church, but it could possibly have been at 140 Court Street and home to the Brockton Gospel Reform Club, which was organized on March 22, 1898, by Daniel S.H. Cobb. In early city directories, the church advertised services at 3:00 p.m. on Sundays. (Courtesy of the Metro–South Chamber of Commerce.)

In 1883, Rev. O.D. Thomas of First Baptist Church held Bible classes under apple trees growing at the corner of North Montello and Snell Streets. When weather turned cold, this group met in local homes, stores, and the shoe factory of Bradford Snell. Formally organized as North Baptist Church on June 3, 1886, the congregation erected this building, which served as its home until replaced with a new facility in 2008.

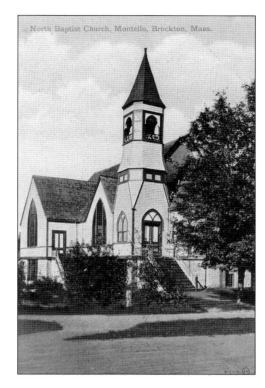

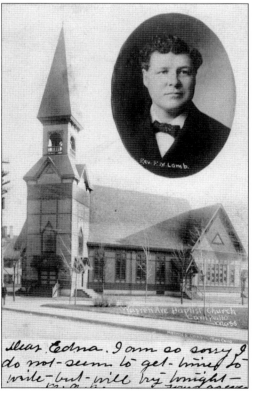

While the North Baptist Church began as a mission on the north end of the city, the Warren Avenue Baptist Church began as a mission in Campello in 1886, first meeting in Huntington's Hall in the Keith Block on Main Street. The church pictured here was considered one of the handsomest in the city when dedicated on February 25, 1891. The inset is of Rev. F.M. Lamb, who served as a member of the Prohibition State Committee in 1908.

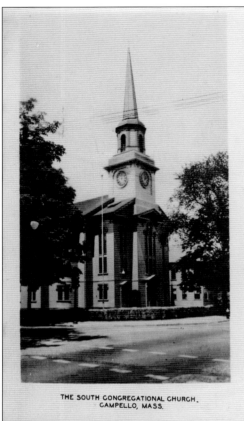

THE SOUTH CONGREGATIONAL CHURCH.
CAMPELLO, MASS.

In 1854, the South Congregational Church building, pictured here, was erected at the corner of Main Street and Perkins Avenue in the heart of the Campello section of the city. Complementing the stately architecture of the neighborhood, it was constructed by local craftsman Bela Keith. The congregation voted in 1980 to join the consolidation of other churches into Christ Congregational Church. The giant shoe manufacturer George E. Keith was a munificent benefactor of the church throughout his lifetime. After its closure, the church sat empty for several years while a battle raged over its future, and eventually, in 1993, the cornerstone of the South Street Historic District was razed and a Walgreen's pharmacy constructed on the site. In the image below, the stately mansard-roofed building remains and is today owned by Ron Bethoney as the home of his antique and brass refinishing business.

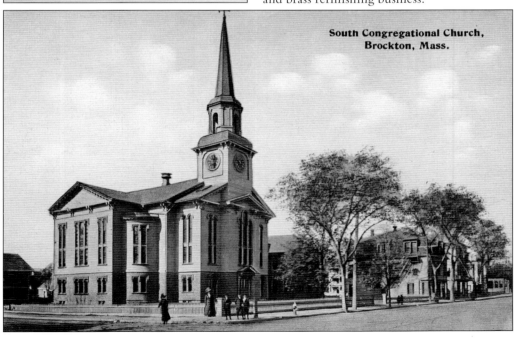

South Congregational Church,
Brockton, Mass.

Two

EDUCATION

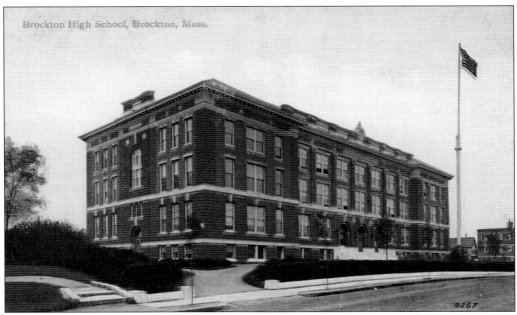

Brockton High School, Brockton, Mass.

Education is one of the chief cornerstones to the success of any municipality, and Brockton, from its earliest days as the North Parish of Bridgewater, has placed a strong emphasis on education. As early as 1746, a school committee was founded, and by the beginning of the 19th century, school districts had been established. In 1827, North Bridgewater had 11 schools, housing 425 students, and the appropriation for operating the schools was $800. By the close of the Civil War, there were 25 schools, 1,525 students, and an appropriation of 7,000. Today, Brockton has over 15,000 students attending 21 schools at a cost of over $150 million. Pictured above is the "A" Building of the old Brockton High School, which was located on Warren Avenue at the top of High Street, now Frederick Douglass Way.

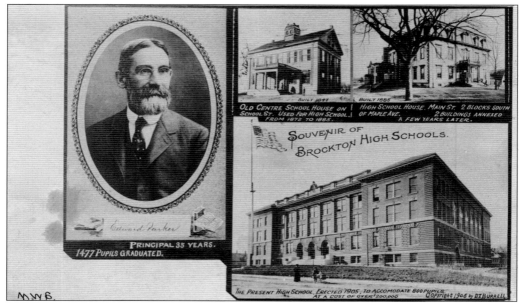

This postcard shows the progression of buildings that served the city as a high school, from the schoolhouse used from 1872 to 1885, to the construction of the city's first school erected specifically as a high school in 1885, to the 1905 building, which was replaced in 1970 with the current high school. Also pictured on this card is Edward Parker. He served Brockton as high school principal for 35 years and oversaw the graduation of 1,477 students. Parker served in all three buildings pictured here.

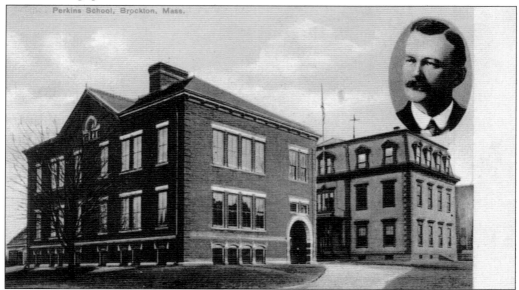

This postcard shows both the old Perkins School and the new brick school that opened in January 1894. These schools were located at the corner of Charles and North Montello Streets. It is uncertain who the school was named for, possibly one or more members of the Perkins family who served on the school committee, or for Samuel C. Perkins, a Civil War veteran. The school was closed in 1975.

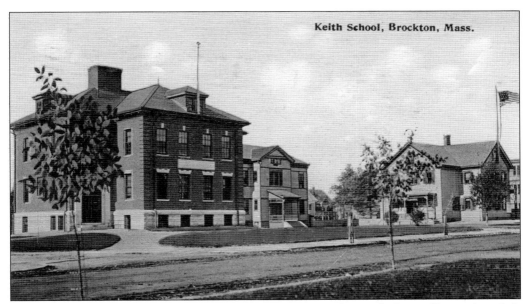

Keith School, Brockton, Mass.

The Keith School was located at 845 Warren Avenue in the city's Campello section. It is assumed that it was named for the Keith family in general. They were early settlers to the area and a prominent family in the shoe industry. The school was erected in 1898 and enlarged in 1907 and 1919. The school was closed due to tax concerns in 1985 and also burned in 1985. A condominium complex was built on the site.

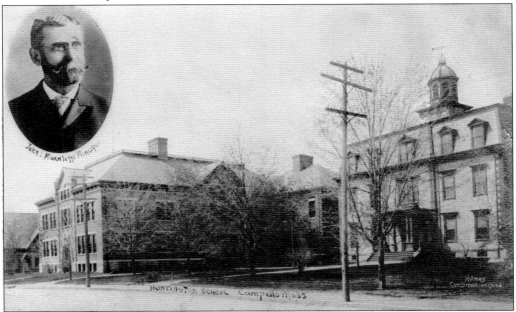

The Huntington School is located in the Campello section of the city. The first schoolhouse was erected on this lot in the late 1700s, and the building at the right was erected in 1842. The brick section was constructed in 1896, and the wooden building was replaced by an addition in 1914. Upon his death in 1858, the school was named for Daniel Huntington, pastor of the South Congregational Church and former school committee member.

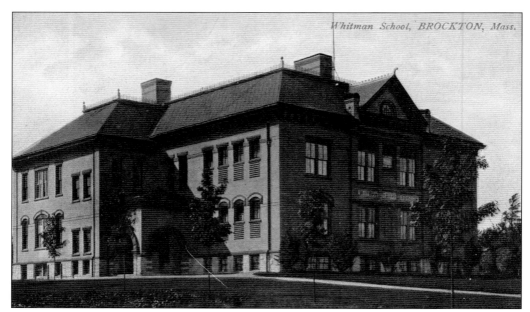

The first Whitman School stood at Main Street and White Avenue, and in 1895, a new Whitman School was erected on Manomet Street. It is commonly believed to be named after Eliab Whitman. Whitman was one of the petitioners to separate from Bridgewater, and when North Bridgewater was established, he became a member of its first school committee. Whitman was also a member of the Massachusetts House of Representatives.

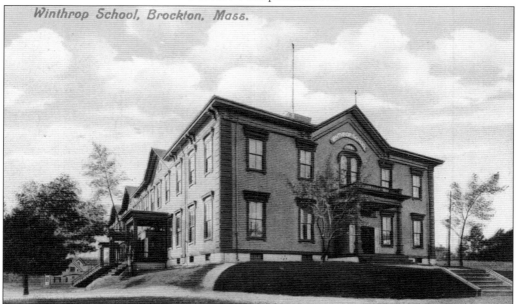

The Winthrop School was built in 1883 on North Main Street and contained four rooms. By 1916, the school had been added to four times. The brick portion of the school served as the first North Junior High. Its name is thought to derive from either the first governor of Massachusetts, John Winthrop, or the Winthrop family of Brockton. In 1997, the school was razed to make way for the new Angelo School.

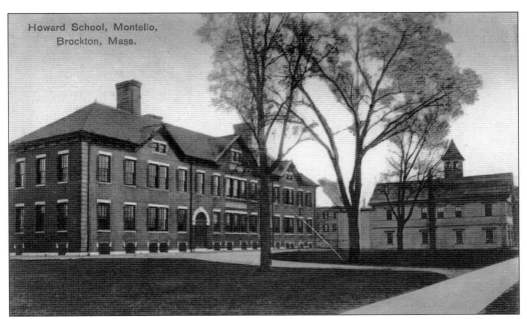

This image portrays the Howard School on North Main Street in Montello as well as the wood-frame Montello fire station. Named for the Howard family, the school is built on the spot where Daniel Howard erected his house in 1721. An addition was built. On July 7, 1945, fire consumed the upper story of the structure, seen here, and the lower floor was capped with a flat roof.

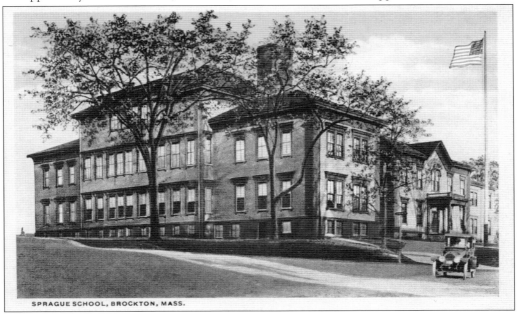

The Sprague School sat at the intersection of Summer and Grove Streets on the city's east side and was named for Chandler Sprague, who established Factory Village at this location. Sprague built his home, a factory, and other industrial sites in this area. This school was, for a time, the home of the administrative offices of the school department; the building was torn down in 1977. Trinity Village now occupies the site.

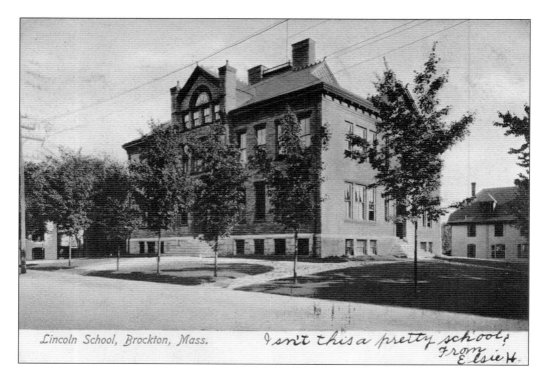

Lincoln School, Brockton, Mass.

Isn't this a pretty school? From Elsie H.

These two postcard images show the Lincoln School on Highland Street. The view above shows the school before the annex was added, as seen in the view below. Whether the wood-frame school from an earlier era or the brick-and-granite structures of the late-19th-century, Brockton's schools were well-built, architectural gems that espoused the wealth of the city derived from its industry. Named for Abraham Lincoln, this building serves as an alternate school today. Only one other city school was named for a US president, the McKinley School, which was located at Sprague Street and Hovendon Avenue.

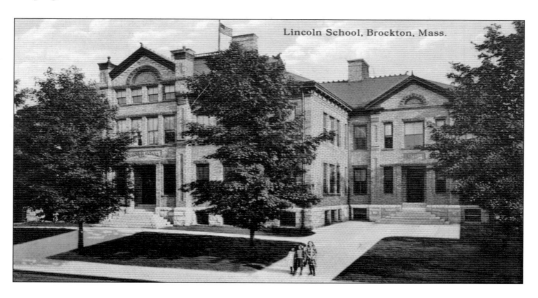

Lincoln School, Brockton, Mass.

The only schoolhouse in the city named for its location was the Forest Avenue School, affectionately known as the "little red schoolhouse." This school stood on Forest Avenue near where the west-side branch of the public library is today. In 1963, a group was formed to preserve this school, and it was moved to the grounds of the current Brockton High School where it remains today, as shown in this image.

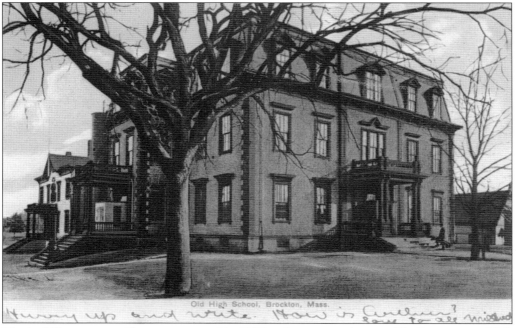

The building portrayed here was erected in 1885 and was erected to specifically serve as a high school. This school, with its distinctive mansard roof, stood where the Brockton Public Library is today. Two additional buildings were annexed to expand the high school as the city population grew, and a new school was constructed in 1905.

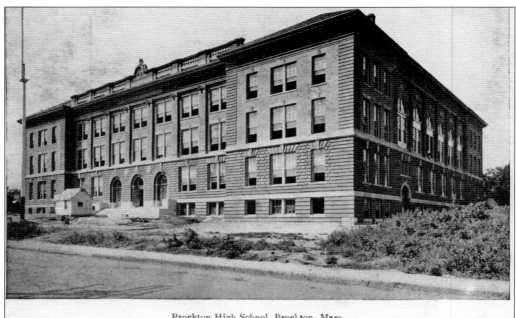

Brockton High School, Brockton, Mass.

In 1905, the city constructed a new high school on Warren Avenue opposite High Street. This new school was erected at a cost of $200,000 and was built to accommodate 800 students. Within a decade, this school was overflowing with students, and the "B" Building was constructed, as shown in the image below. By the 1960s, overcrowding forced split sessions, and in 1965, it was decided a new school was needed. The new Brockton High School opened in 1971. The A Building of the old high school would be demolished, and the B Building would become the William H. Arnone School until a new school by that name was constructed; today, the B Building serves as the Eldon B. Keith School.

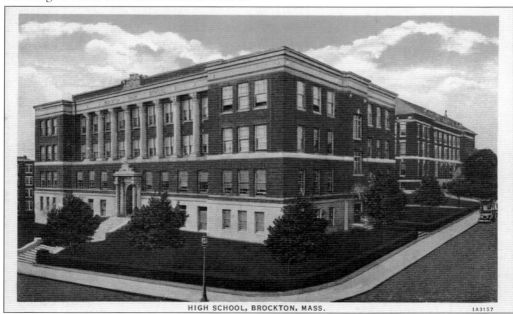

HIGH SCHOOL, BROCKTON, MASS. 1A3157

Three

BROCKTON FAIR

The Brockton Agricultural Society held the first Brockton Fair in October 1874. From its inception, thousands flocked to this fair annually, and it continues to this day, though now held in June-July and much less agricultural than when first begun. In its early years, many of Brockton's prominent businessmen were involved in fair operations. Pictured here is William B. Cross, president of the fair and owner of the W.W. Cross nail and tack manufacturing company. In 1888, Cross was listed among the 20,000 richest people in New England based on what they paid in taxes; Cross's taxes for 1888 were a whopping $200. Only twice has the fair not been held—in 1918, due to the influenza epidemic, and in 1943, due to lack of manpower and transportation because of World War II.

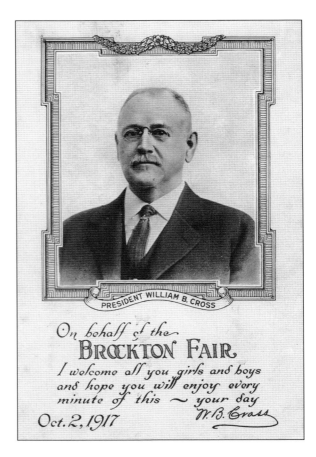

PRESIDENT WILLIAM B. CROSS

On behalf of the
BROCKTON FAIR
I welcome all you girls and boys
and hope you will enjoy every
minute of this ~ your day
Oct. 2, 1917
W.B. Cross

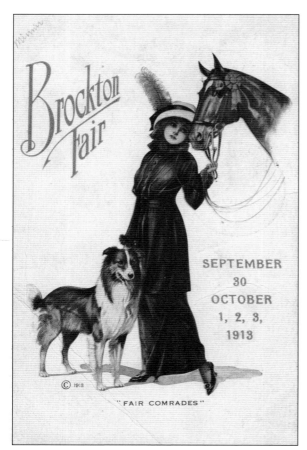

As portrayed in this card advertising the 1913 fair, attending the fair was considered the social event of the season for men, women, and children of all ages. As was the custom of the day, people dressed formally for the occasion. The fair's horse show was a major attraction, and so were the numerous livestock exhibits.

Postcards were one way that the fair promoted itself and its exhibits. This card from 1922 shows a crowd around the Indian Village, which was an exhibit depicting Native American life at the time when the Wampanoag people inhabited the area. Actual Native Americans from Maine were featured in the exhibit. The inset shows the superintendent of concessions, Charles H. Pope, one of the key figures in operating the successful event.

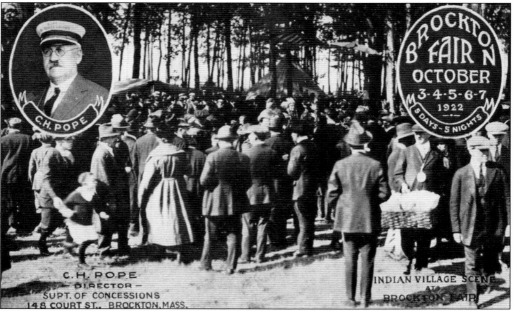

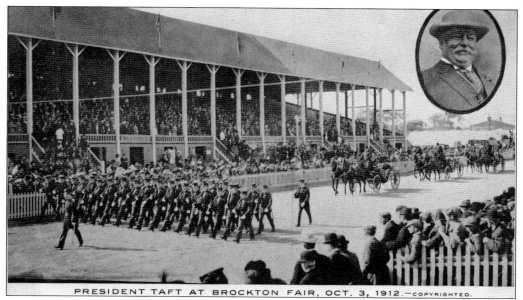

A month before the presidential election of 1912, sitting president William Howard Taft visited Brockton and attended the fair on October 3. Taft had been renominated by the Republicans and was in a rare four-way race with Woodrow Wilson, the Democratic nominee; former president Theodore Roosevelt on the Progressive Party ticket; and Socialist candidate Eugene Debs. Wilson was victorious while Taft placed third behind Roosevelt.

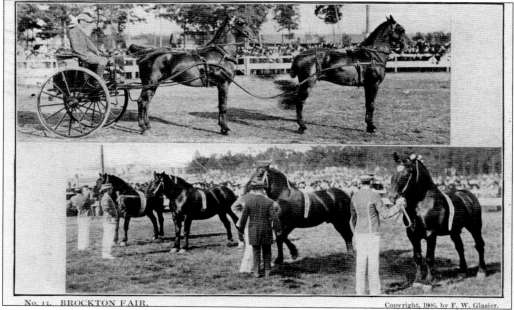

The horse show was one of the fair's highlights. In 1906, these images captured that event and were taken by photographer Frederick Whitman Glasier. Glasier was born in Adams, Massachusetts, and settled in Brockton in 1890. A prolific photographer of Native Americans, as well as the circus and performers, Glasier took many photographs of the Brockton Fair. Glasier died in Brockton on July 28, 1950, at the age of 84.

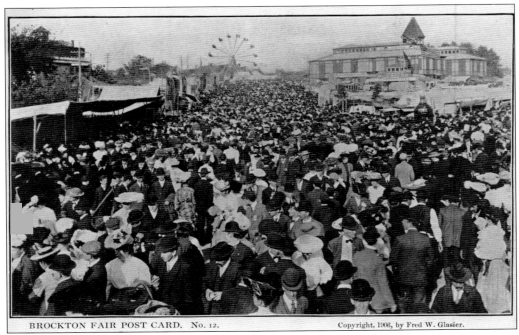

These two postcards, with images by Glasier, show the crowded fair concourse. In the above photograph, a Ferris wheel can be seen in the background. The Ferris wheel had only been in existence for 13 years when this photograph was taken in 1906; the Brockton Fair was always a leader in showing off the latest in technology and amusements. In the image below, one can see the many concessions and sideshows of the fair that surrounded the racetrack as well as administration buildings at the rear. The fairgrounds had its own police department substation on site as well as a fire station. Police patrolled the fair on foot, horseback, and by motorcycle to assure the safety of the immense crowds. In 1929, more than 300,000 people attended the fair.

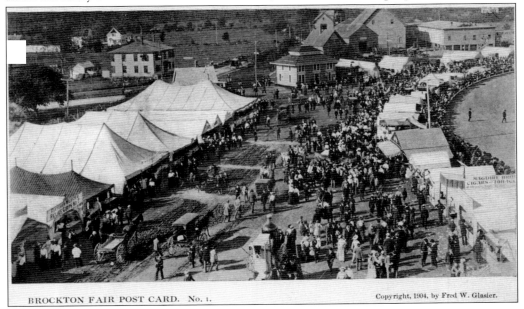

The Brockton Fair gave local farmers the opportunity to show off their prize crops and livestock. Daniel W. Field and his brother Fred were noted farmers in the area, and their Oak Street Dutchland Farm was world famous. Among their herd was Aaggie Cornucopia Pauline 2nd. This cow held many records, including making 31.04 pounds of butter from 679.40 pounds of milk in seven days and making 102 pounds of milk in a single day.

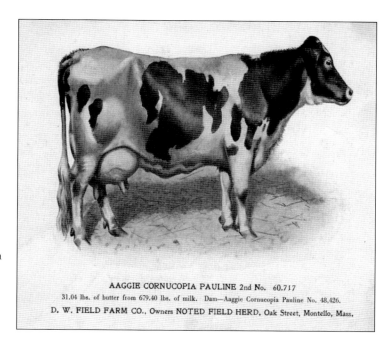

AAGGIE CORNUCOPIA PAULINE 2nd No. 60.717

31.04 lbs. of butter from 679.40 lbs. of milk. Dam—Aaggie Cornucopia Pauline No. 48,426.

D. W. FIELD FARM CO., Owners NOTED FIELD HERD, Oak Street, Montello, Mass.

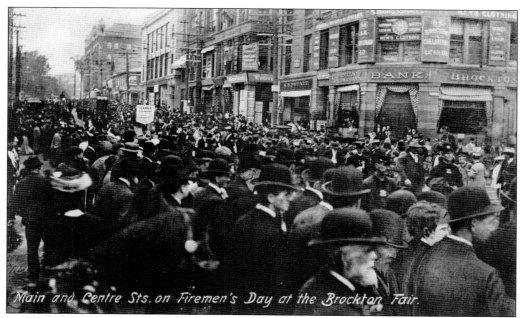

A huge crowd gathers on Main Street as the fire department parades by on its way to the fairgrounds to celebrate Firemen's Day. Firemen from throughout the region converge on the fair with their antique hand tubs to participate in musters and win ribbons, trophies, and cash prizes for their fire companies. Several Brockton companies, such as Hancock, Protector, and Enterprise, participate in these musters. In the immediate background of this image is the Bryant Building as well as the Enterprise Building.

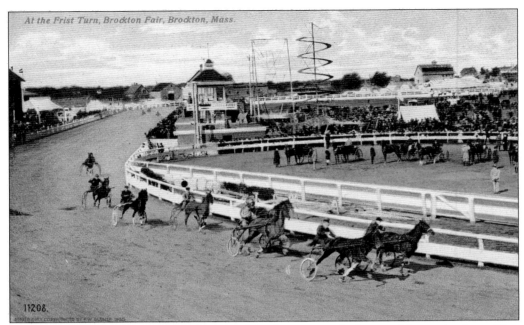

At the Frist Turn, Brockton Fair, Brockton, Mass.

11208.

Horses have always been an integral part of the fair scene, whether workhorses in the pulling contests or the horses on the track. Brockton was famous for its trotting and pacing events, and many world records were set at the track. The track required a lot of maintenance during the fair as it was used for both horse and auto racing once automobiles came into vogue. The importance of the horse at the fair was made evident in 1929, when fair president Fred Field had a meetinghouse for horsemen erected. This meeting place provided a place for horsemen to talk about their trade as well as attain amenities such as a barbershop, lunch room, and showers, as promoted, with "a continuous supply of hot water for man and horse."

Brockton Fair, Brockton, Mass.

11209.

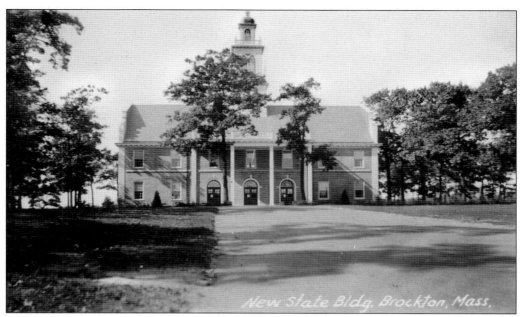

The Commonwealth of Massachusetts erected an exhibition on the fairgrounds around 1931. Architect James H. Ritchie, who also designed the city's War Memorial Building on West Elm Street, designed this structure. Similar in scope to the state building at the Big E in Springfield, this was a place to promote Massachusetts and its commerce, and though in disrepair, the structure still remains.

Most of Brockton's ethnic groups were represented in some way at the fair, many in tents with ethnic displays and food. This card shows a more elaborate Italian exhibition building named in honor of Guglielmo Marconi, the inventor of long-distance radio transmission. This building was a part of the International Village at the fair, where the Lithuanian, Irish, and French also had permanent structures.

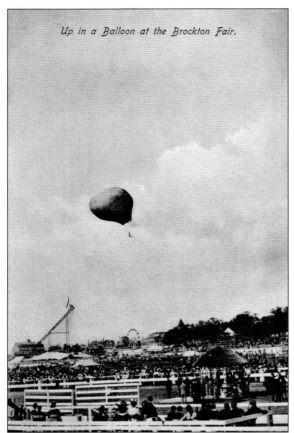

Up in a Balloon at the Brockton Fair.

The exhibition of hot air balloon flight over the fairgrounds was a perennial favorite of the crowd. Each year, Prof. T.H. Flowers of Boston, the owner of the American Balloon Company, would arrive in Brockton to put on his spectacle of flight. When new methods of flight were showcased at the fair, the balloon remained a major attraction. Flowers would employ aeronauts who would parachute from the balloon or perform trapeze acts while in flight. The fairgrounds boasted a seven–acre parcel for parking automobiles and could accommodate 5,000 vehicles. Ink manufacturing magnate George Morrill of Norwood, Massachusetts, drove his automobile to the fair in 1895, making it the first automobile to be seen at the fair; it was said to be a greater attraction than the balloonist.

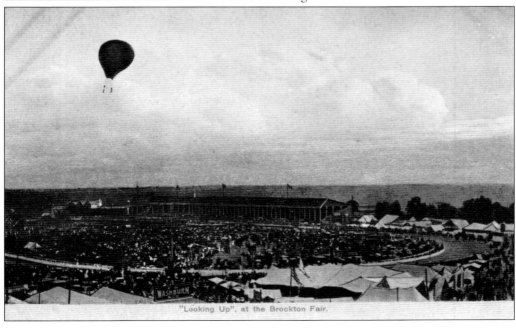

"Looking Up", at the Brockton Fair.

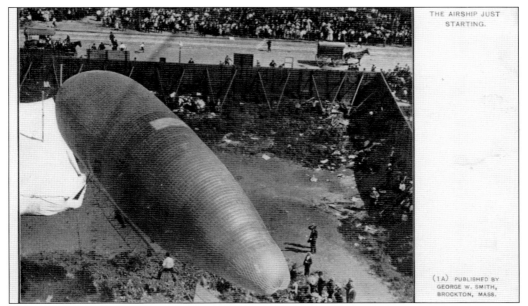

In 1905, just two years after the Wright brothers' flight, Brockton was treated to the flight of a steerable balloon, or dirigible. L. Roy Knabenshue, like the Wrights, was from Ohio and, in 1904, piloted the first dirigible seen in America at the St. Louis World's Fair. Knabenshue would appear in Brockton several times with his airship, which, as can be seen in this image, looks like an oversized potato.

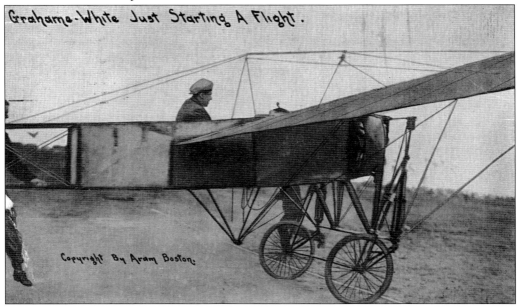

Grahame-White Just Starting A Flight.

Copyright By Aram Boston.

Among the several aviators to fly at the Brockton fair was the English pioneer of aviation, Claude Graham-White. The first man to make a night flight, Grahame-White was not a major risk taker. Once at the Brockton fair, he refused to fly due to heavy crosswind, disappointing a crowd of 120,000. His remark to the crowd was, "I can buy a new airplane ladies and gentlemen, but I cannot buy a new life."

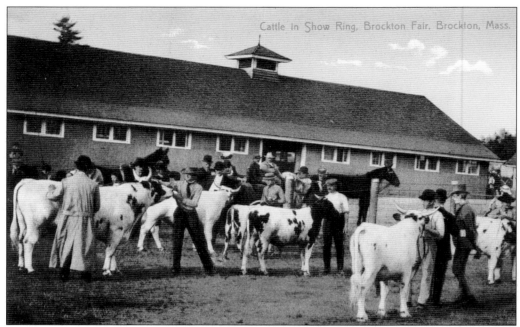

The showing of cattle was another major event of the fair, as depicted in these two postcards. In the above image, cattle are being lined up and prepared for show by their owners. In the image below are two of the prize animals from Daniel W. Field's herd. On the left is Dutchland Sir. On the right is Colantha Johanna Lad, No. 32481, which was the highest-bred bull around 1914. Fred Field was a director of the Holstein-Friesian Association of America, which was a group of cattle breeders that kept a close pedigree and census of all cattle of that breed. Other Brockton members of the association were Walter T. Packard and William J. Rankin.

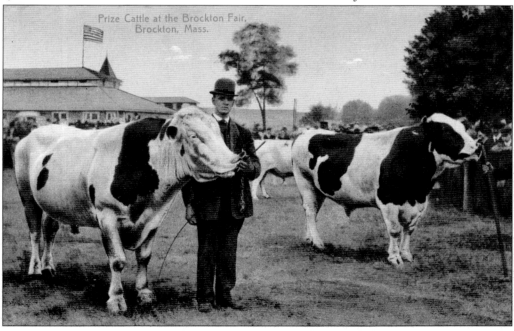

Four

FIRE DEPARTMENT

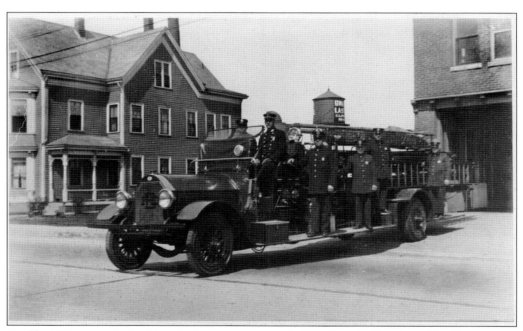

Bradford Kingman, in his historical writings, wrote in 1895 that the Brockton Fire Department was "often referred to as one of the most efficient and best managed of any in the country." Fire protection began in the town as early as 1827 with the purchase of a bucket tub; over time, hand tubs would be purchased, followed by horse-drawn steamers, and eventually motorized engines, such as the one pictured here outside the Battles Street station. This station was located at North Montello and Battles Streets and is now home to the Cape Verdean Association. (Courtesy of the Brockton Historical Society Fire Museum.)

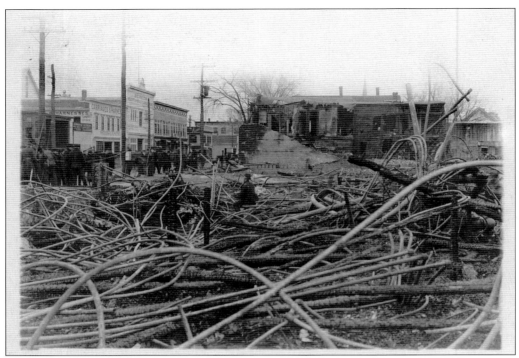

On March 20, 1905, one of the worst conflagrations to befall the city occurred when the boiler at the R.B. Grover shoe factory at the corner of Main and Calmar Streets in Campello exploded. In a matter of minutes, the wood-frame factory was reduced to rubble. The image above, looking south, shows the twisted debris as well as the collateral damage to other neighboring businesses and residences. The photograph below shows a somewhat cleaned-up site fenced off with curious onlookers lined up on the sidewalk. The towers of the Swedish Congregational and Swedish Methodist Churches can be seen in the background. Fifty-eight people perished in the fire.

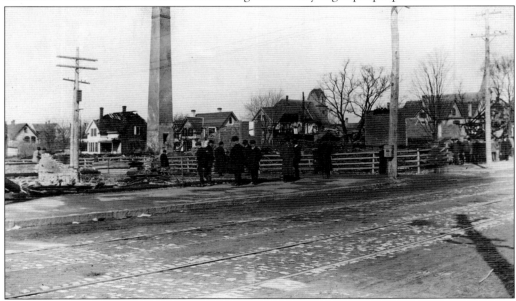

An act of the Massachusetts legislature created a fire department in the city in 1865. On October 5, 1892, Harry Lovell Marston became the first official chief of the department. Marston began his career as a volunteer with the department in 1876 and in 1886 became a paid member. Pictured is the first assistant chief of the department; he is unidentified.

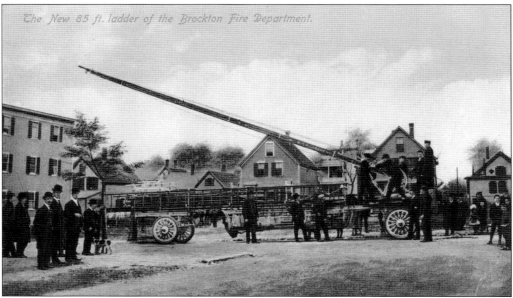

Pictured here is Brockton's 85-foot aerial ladder. In 1902, it was reported that the city was comprised of many four- and five-story factory buildings and many three-story residential structures, necessitating the need for such an apparatus. Well prepared, the same report indicated that city had 650 hydrants and 9,900 feet of good cotton hose. The 1902 report indicated that the department had $70,000 worth of equipment and $39,000 worth of buildings in which it was housed.

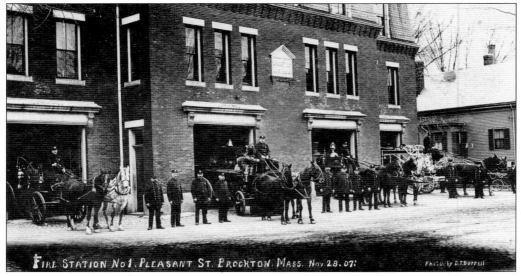

In 1884, Brockton constructed station No. 1 on Pleasant Street. Brockton architect Waldo V. Howard designed the building in the Second Empire style. Still in use today, this station was the first in the nation to be operated electrically when opened on December 30, 1884. It is said that Thomas Edison personally oversaw the installation of electricity into this building. (Courtesy of the Brockton Historical Society Fire Museum.)

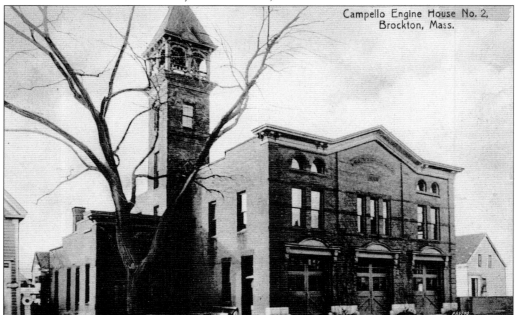

In 1888, construction began on a new brick firehouse in the Campello section of the city. Dedicated on January 24, 1889, station No. 2 also included a police station, which can be seen in this photograph at the bottom and to the left of the hose tower. Stations of this vintage had hose towers in which firemen could hang hoses to dry so that they would not rot. Many of these towers also contained bells for signaling. Today, the bell from this station is on the front lawn of Brockton's Fire Museum.

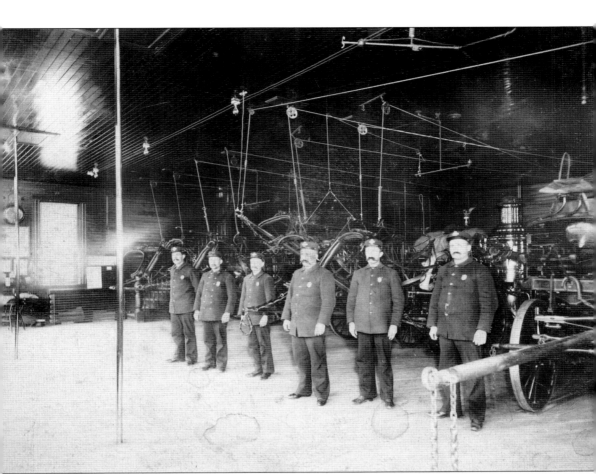

This image shows the men of station No. 2 lined up in the firehouse in front of their equipment, which includes horse-drawn steamers as well as hose and chemical wagons. Hanging from the ceiling is an array of pulleys and cables all holding in place the harnesses for the horses. The horses were in stalls at the rear of the station, and when the alarm sounded, they were brought forth and the harnesses lowered quickly into place; the apparatus and horses were out the door in a matter of seconds. Note the row of electric lights in the ceiling as well as the two firemen's poles in the left foreground. This station remains in active use today. (Courtesy of the Brockton Historical Society Fire Museum.)

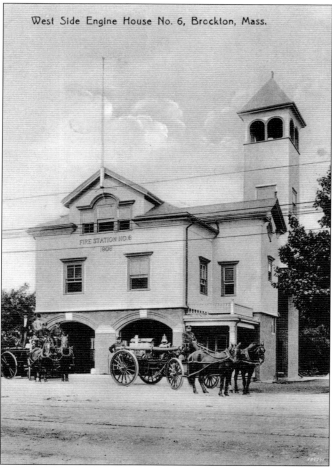

West Side Engine House No. 6, Brockton, Mass.

Fire station No. 4 was constructed in 1895 in the Romanesque Revival style on the city's east side. Erected the year before Brockton abolished its railroad grade crossings, it was an answer to the concern that freight trains were often large enough to block all five streets leading to the east side, thus prohibiting fire apparatus from responding in a timely manner and contributing to the fact that insurance rates were higher on the east side.

Pictured here is station No. 6 on the west side, which was built in 1906 at a cost of $11,000. In front is the latest in fire apparatus technology, though still pulled by horses. The attached pumper featured a gasoline-powered engine rather than steam. This was the first of its type purchased in the United States. The cost was $4,000, and it is reported that Brockton eventually owned two of the six manufactured.

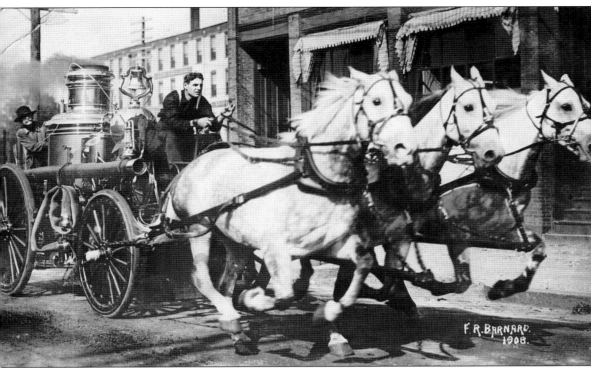

Perhaps the most iconic of all Brockton Fire Department photographs is this 1908 image by Frank R. Barnard. This steamer was responding at breakneck speed to a fire on East Railroad Avenue. The most amazing part of this photograph is that all of the hooves of all three horses are off the street simultaneously, an indication of the speed at which they were travelling. Note the intenseness of the driver and the fireman. These three white horses, named Billy, Major, and Pedro, served the city until retirement, when motorized vehicles replaced them. During World War I, they were shipped to Europe to serve in the war effort. On route, the ship carrying them was torpedoed, and the lives of these three Brockton horses ended. It is believed that some eight million horses died in World War I. (Courtesy of the Brockton Historical Society Fire Museum.)

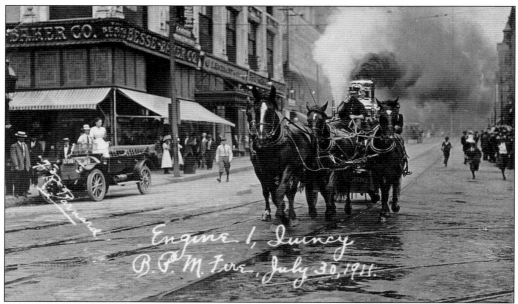

*Engine 1, Quincy
B. P. M. Fire, July 30, 1911.*

On Sunday, July 30, 1911, at 4:09 a.m., a major fire broke out in the Brockton Public Market, known as the BPM, at 161 Main Street. The fire swept through the store and adjoining buildings in no time. More than the Brockton Fire Department could handle, mutual aid was called for from the surrounding area. Most of the surrounding towns had limited firefighting resources, and so aid was also called from Quincy and Boston. The above image shows the Quincy pumper coming down Main Street, driven by Herbert Griffin. Adding a fourth horse to the hitch, the Quincy pumper was on scene in less than an hour. In the image below, aid arrived from Boston via railroad. Leaving Braintree at 6:59 a.m., the train arrived in Brockton at 7:11 a.m. (Courtesy of the Brockton Historical Society Fire Museum.)

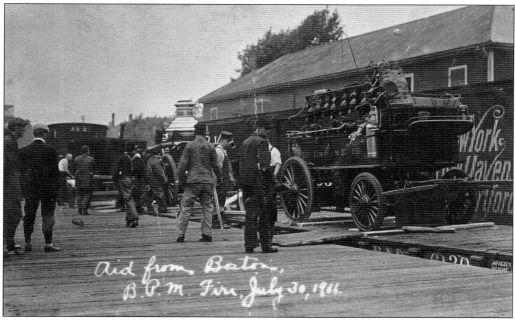

*Aid from Boston,
B. P. M. Fire, July 30, 1911.*

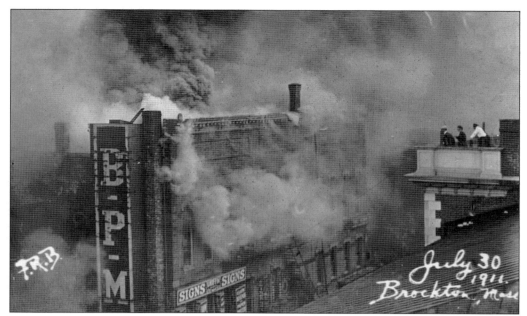

These two postcards show the BPM fire at the height of the blaze and the ruins of the Satucket Block in the aftermath. In addition to the BPM Building and the Satucket Block, the Holbrook Building was also a total loss. The Satucket Block was owned by Bradford Jones, while the Holbrook Building was owned by Susan (Cross) Holbrook and was only two years old when destroyed. By the Thursday following the fire, Maynard Davis, owner of the BPM, had a temporary store set up and equipped on East Elm Street. Two days later, the J.W. Shaw Company at 31 Main Street sold out to Davis, and the BPM was back in operation on Main Street. In March 1912, the store moved back to its rebuilt 161 Main Street location. (Courtesy of the Brockton Historical Society Fire Museum.)

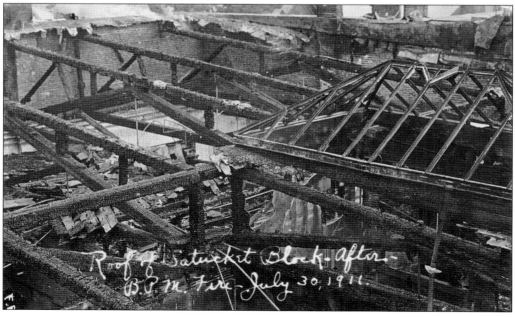

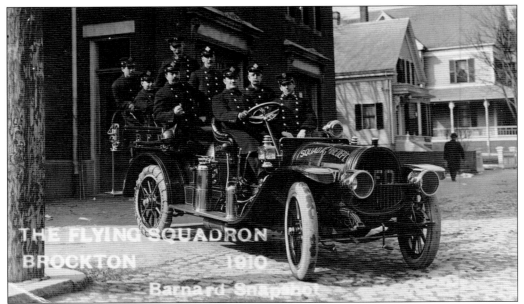

This 1910 postcard shows Brockton's famous "Flying Squadron," Squad A. This squad was established to be a first responder and aid the other fire companies on scene. The concept of this squad was put into place on December 20, 1909, and assistant chief William F. Daley was put in command. The importance of the squad grew when Daley became chief, and by the early 1920s, the squad was responding to more than 400 calls per year. (Courtesy of the Brockton Historical Society Fire Museum.)

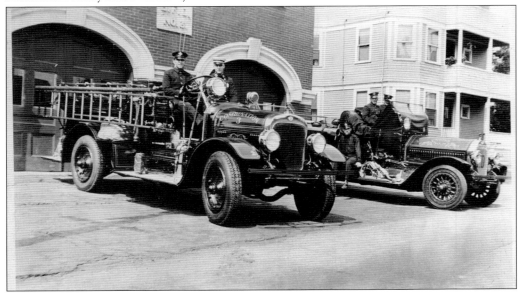

Two of Brockton's early motorized fire engines are being displayed in front of station No. 3 on North Main Street. This station was built in 1898 to replace the wooden firehouse, which was a short distance to the south. Italianate in design, it was designed by Waldo V. Howard. Its beautiful arched doors were eventually made square to accommodate modern equipment. (Courtesy of the Brockton Historical Society Fire Museum.)

Five

Public Service

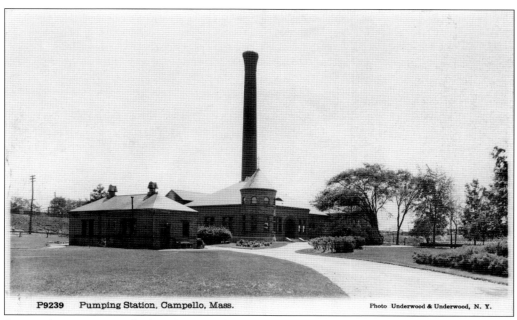

P9239 Pumping Station, Campello, Mass. Photo Underwood & Underwood, N. Y.

As Brockton grew in the last decade of the 19th century, its public buildings reflected the prosperity of the area and were given grand and graceful designs. Only the large chimney belies the fact that this Romanesque Revival building, constructed in 1893, is not something other than the sewer pumping station that it is. Brockton constructed one of the world's most technically advanced sewer systems in the 1890s; even the king of Siam came to visit it.

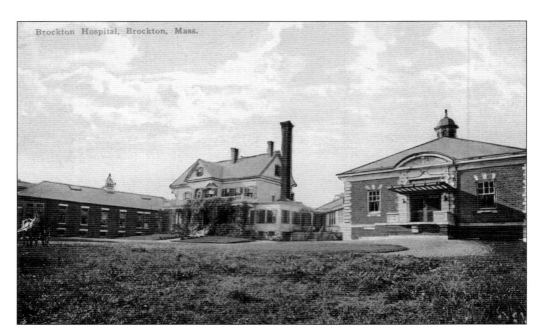

In March 1890, Brockton businessman George Clarence Holmes declared, "More than it needs a city hall, more than it needs a system of sewage or memorial hall . . . does Brockton need a hospital." Holmes was probably right, for at the time, the city's population was approaching 30,000, and there was no hospital. By March 14, 1896, the Brockton Hospital had become a reality. The hospital was constructed on the nine-acre estate of George Henry Kingman, purchased for $11,000 and located on Centre Street far out on the east side. In 1910, the hospital was comprised of 50 beds and was reported as having served 395 paying patients, 56 partially paying, and 249 free. Though much enlarged and modernized, the hospital still occupies its original site.

BROCKTON HOSPITAL, BROCKTON, MASS.

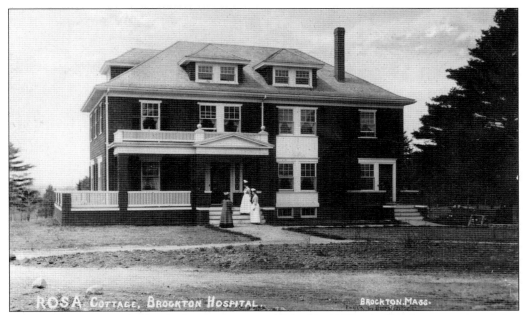

The Brockton Hospital School of Nursing was established in 1897 and offered a two-year training program. In 1935, the school closed as a result of the Great Depression but opened eight years later when the need for nurses increased due to World War II. Pictured here is Rosa Cottage, the nurses' residence, a gift from Daniel Waldo Field, who named it for his wife Rosa.

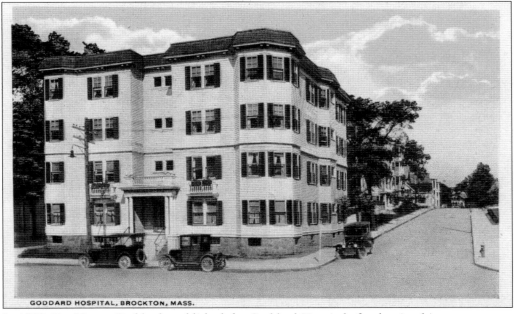

In 1902, Dr. Henry Goddard established the Goddard Hospital after leaving his post as pastor of the New Jerusalem Church of Brockton, which was where he had been for 19 years. His son Dr. Samuel Goddard joined his practice in 1908. The Goddard Hospital was located in various locations at various times; the location pictured here is on Warren Avenue at the top of Legion Parkway. Today, it is an apartment house.

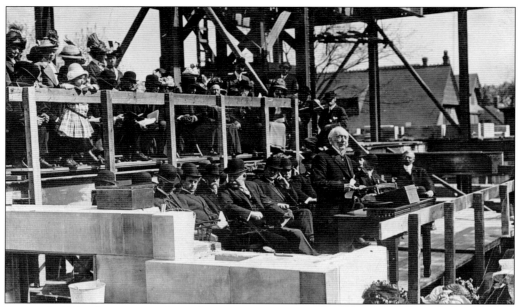

In March 1857, the citizens of North Bridgewater voted to purchase a town library; however, this vote would be rescinded, and it would be a decade later, on March 4, 1867, that the town approved a free public library. Use of this new library soon put many critics to rest when, in the first five months, the library had a collection of 2,200 volumes and 995 borrowers. The first home of the library was in the Studley Block at Main and High Streets, where the Goldthwaite Block is today. Later, it was housed in the Satucket Block and eventually moved to the new city hall. Ultimately, the city would procure funds through steel tycoon Andrew Carnegie, and on May 15, 1912, the cornerstone was laid, as pictured above. The completed building, shown below, was opened for the first time on June 10, 1913.

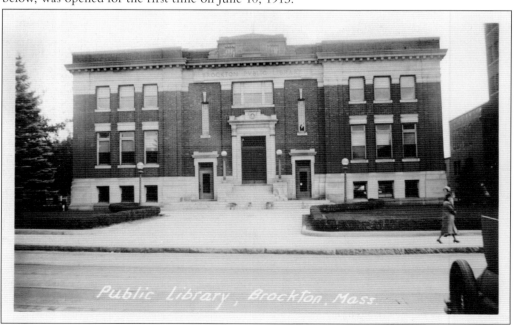

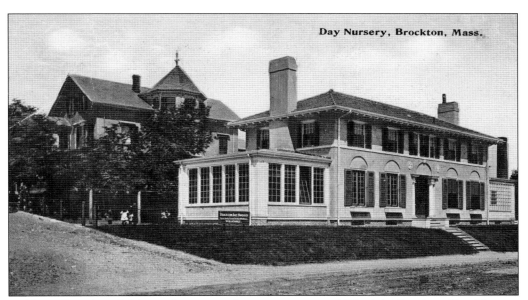

Day Nursery, Brockton, Mass.

Led by Leila Delano Richmond, a group of young woman established the Brockton Day Nursery (BDN) "to care for young children during the working hours of the mother." This effort was recognized by shoe manufacturer William L. Douglas, and in 1908, Douglas presented the organization with the beautiful building pictured here on Everett Street. This building was demolished in 1968, and today, the BDN operates out of its facility on Crescent Street.

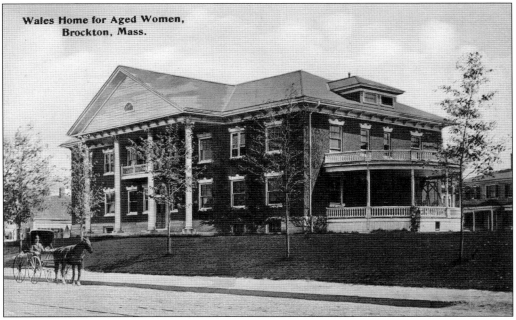

Wales Home for Aged Women, Brockton, Mass.

In 1892, woman from the city sought to establish a home for aged women. In 1893, Catherine P. Cobb gave the group the 1811 Wales homestead provided they name their new house the Wales Home. In 1901, Daniel Waldo Field had the building pictured here constructed on the land Cobb had given. Today, this building is home to the Ruth House, operated by Lutheran Social Services of New England.

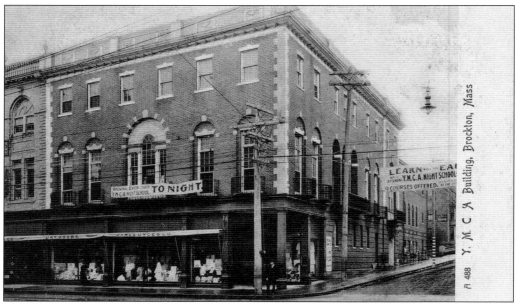

The Brockton Young Men's Christian Association was formed in 1887 and is today part of the Old Colony YMCA group of facilities. Pictured above is an early home of the Y above the dry goods store of James Dyce, located at 167–181 Main Street. In 1913, under the leadership of association president Daniel A. Howard, the cornerstone was laid for a new $200,000 facility, pictured below, which would be opened in the fall of 1914. Among those who have benefited by their association with the Y was Watt Terry, a black Brocktonian who worked at the Y as a janitor in the first decade of the 20th century, worked his way up through the shoe factory, and eventually became involved in real estate. By 1913, Watt owned 222 buildings in Brockton and was bringing in upwards of $7,000 in rent annually.

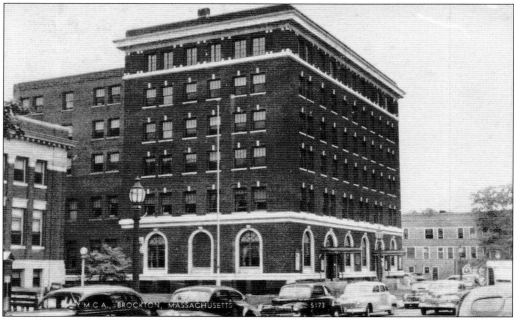

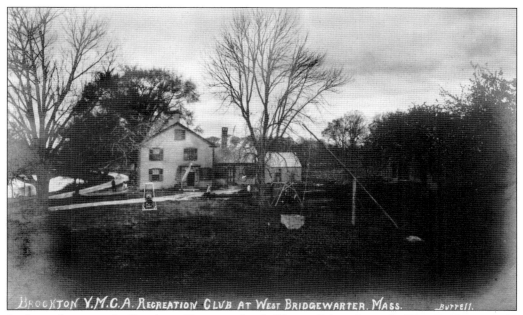

In the early years, the Brockton Y operated a facility on River Street in West Bridgewater in the home built in 1677 by Jonathan Howard. This building would later house the Americanage Canoe Club as well as be home to congressman Hastings Keith. The building remains a private home today.

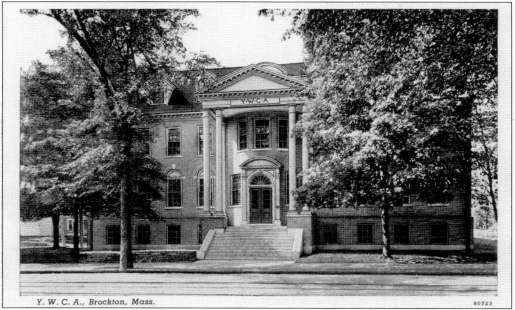

Brockton's Young Women's Christian Association building, pictured here, was constructed in 1918. This building was designed by Francis R. Allen and Charles Collens, renowned New York architects who also designed Union Theological Seminary and the Cloisters museum on Manhattan as well as the Thompson Memorial Library at Vassar College and the Newton, Massachusetts, city hall. This building is currently a part of the Old Colony Y group of facilities.

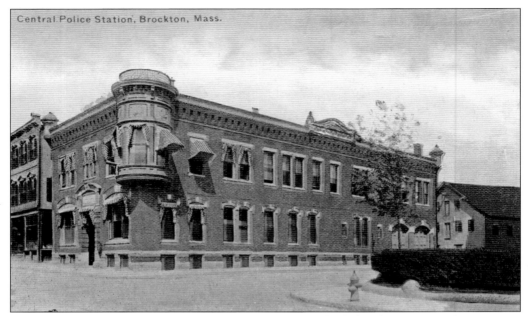

Central Police Station, Brockton, Mass.

In 1968, Pres. Lyndon Johnson's War on Poverty helped lead the charge across the nation to tear down anything old. Among the victims of this wanton destruction was the headquarters of Brockton's police station on School Street, opposite city hall. Ironically, the new police station was built where the Old Colony Railroad station had once stood, another victim of urban destruction. The old police station had once held the criminals Sacco and Vanzetti.

City Farm, Brockton, Mass.

The poor farm was a standard government fixture in many towns in the 19th and early 20th centuries. Indigent residents would be given food and shelter at these farms in exchange for working the farm. These farms produced most of all the produce, meat, and milk that were consumed by the residents. Brockton's poor farm was located on Thatcher Street where Massasoit Community College is today.

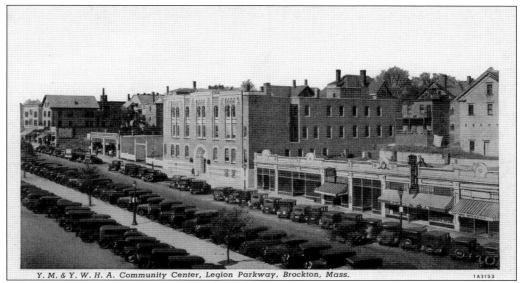

Y. M. & Y. W. H. A. Community Center, Legion Parkway, Brockton, Mass. 1A3153

Dominating the neighboring buildings, the home of the Young Men's and Young Women's Hebrew Association was located on the north side of Legion Parkway. Many prominent members of Brockton's Jewish community were members and supporters of the association, including Dewey Stone, who figured prominently in the formation of the state of Israel. Kenneth Feinberg, special master of the September 11th Victim's Compensation Fund, spent many hours of his youth here.

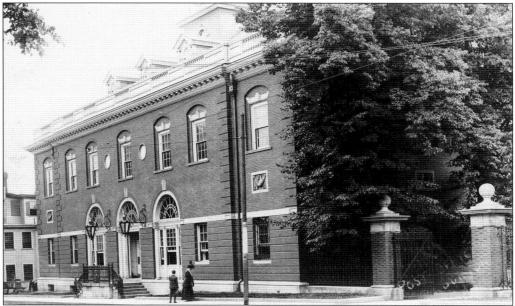

The former Brockton Post Office on Crescent Street was designed by James Knox Taylor, who was the supervising architect of the US Department of the Treasury from 1897 to 1912. A graduate of the Massachusetts Institute of Technology and later head of its architectural department, Knox designed many post office buildings, Brockton's being constructed in 1898. Today, this building houses the administrative offices of the Brockton School Department.

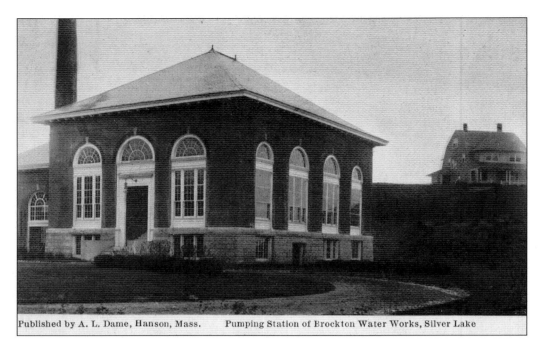

Published by A. L. Dame, Hanson, Mass. Pumping Station of Brockton Water Works, Silver Lake

On May 10, 1899, the Massachusetts legislature granted the City of Brockton the right to take water from Silver Lake, some 20 miles away in Pembroke, Kingston, and Plympton. The pumping station shown here was erected in Hanson. Perennial water supply issues caused the city to enter into an agreement with a desalinization plant in 2002 to alleviate the supply issue.

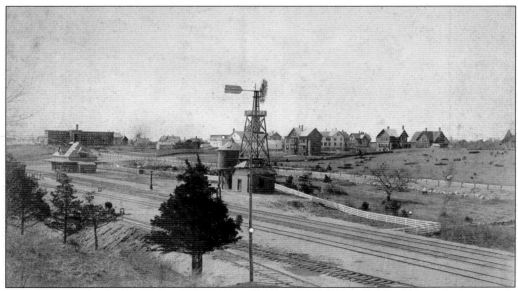

This c. 1888 image shows the Montello station and the shoe factory of William L. Douglas directly behind the station house. This station was constructed by Daniel W. Field and his father, whose shoe factory was on the west side of the tracks. The Fields entered into an agreement with the rail line that if they built the station, the train would stop to pick up goods to ship to market.

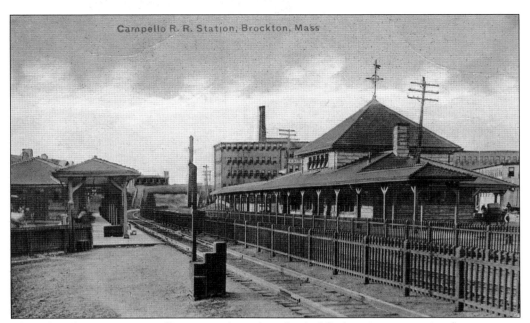

The railroad station at Campello was a major point of arrival for immigrants coming from overseas to work in the shoe factories of Brockton. It was located alongside the massive complex of the George E. Keith Company, and no doubt, it was the point from which Keith and his executives departed on countless trips around the world promoting their Walk–Over brand of shoes.

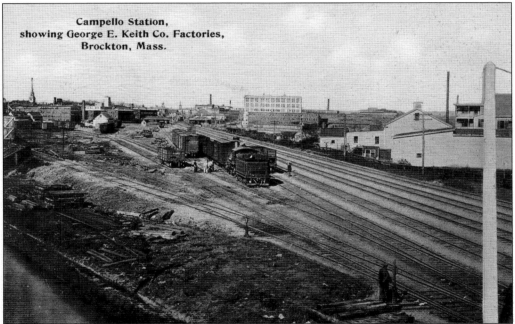

Perhaps the busiest of Brockton's freight yards was that located at Campello. Millions of pairs of shoes were shipped from this yard. Tons and tons of coal were received at this yard and disbursed throughout the city to power the industrial machine. The large structure in the background is the executive building of the George E. Keith Company.

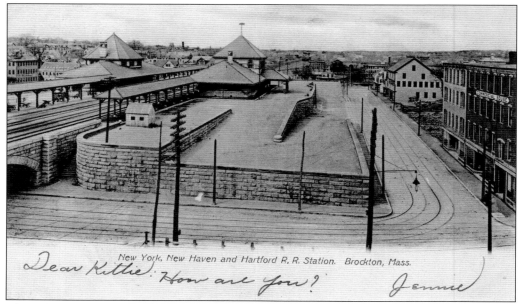

New York, New Haven and Hartford R. R. Station. Brockton, Mass.

Dear Kittie How are you? Jennie

The railroad was perhaps one of the biggest reasons for the city becoming a major manufacturing center in the late 1800s. The Old Colony Railroad bisected the city and was serviced by three stations and large freight yards. When grade crossings were eliminated in 1896, this new station was constructed downtown with duplicate buildings on both sides of the tracks. This station became a victim of urban renewal in 1968, with the southbound station side completely obliterated and the northbound station side removed; the new police station was built upon the terraced landscape. The image below depicts the massive crowds that connected with the trolley for transport to the fairgrounds. Note several carriages near the platform to deliver passengers as well as freight to their appointed destination.

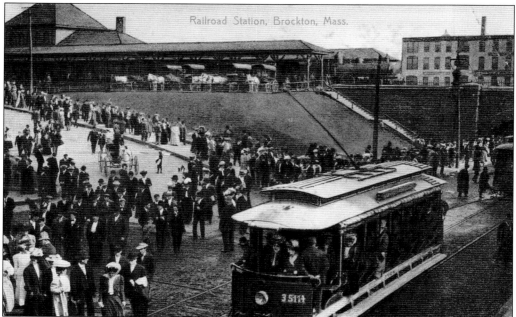

Railroad Station, Brockton, Mass.

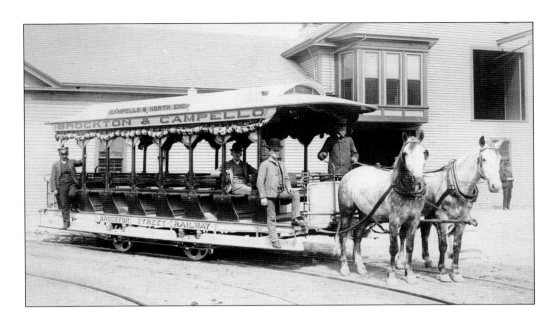

In 1881, the Brockton Street Railway Company was formed by a group of prominent businessmen, including Ziba Keith, who would become Brockton's first mayor. Capitalized with $40,000, the company owned 6 boxcars, 3 open cars, and 39 horses. The operation began on July 6, 1881, with the running of cars from Clifton Avenue in the south, through downtown, and terminating in Montello. Trips were at 20-minute intervals. Shortly after beginning operations, the company purchased several large omnibuses, two of which are pictured here at the stables. Note the tracks coming out of the stables and also the curved tracks to allow for the turning of the cars at the line's terminus. It would not be long before electric streetcars put this horse-drawn line out of business.

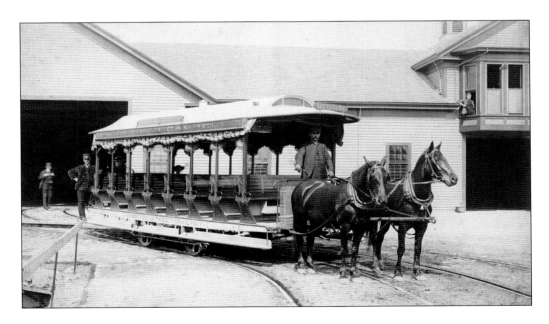

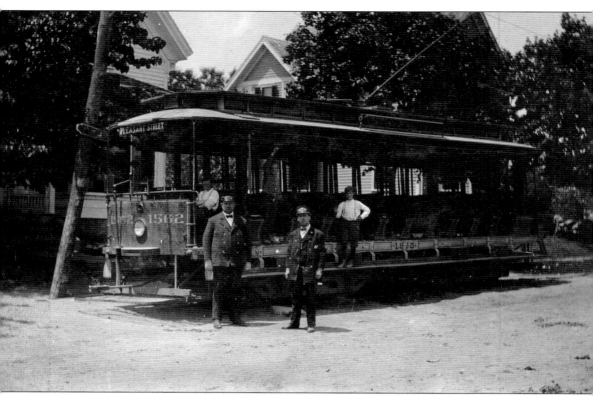

On September 5, 1890, Brockton's electric streetcars went into operation, and a network of tracks and trolleys crisscrossed the city and surrounding towns. This line carried workers from the suburbs to work in the city as well as brought people of all ages to the city for shopping, dining, and entertainment. The age of the electric trolley in Brockton came to an end on July 11, 1937, when the last car returned to the barn.

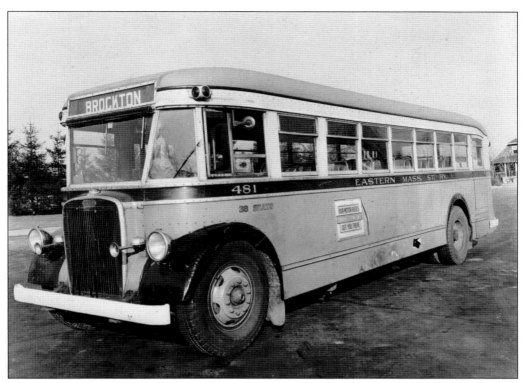

The Eastern Massachusetts Street Railway Company began as an electric car line, eventually switching to busses to cover a great portion of eastern Massachusetts. Pictured here is a bus from that line serving Brockton. Many of the routes of this old line are still operated by the Massachusetts Bay Transportation Authority in communities in the immediate Boston area. (Courtesy of the Brockton Historical Society Fire Museum.)

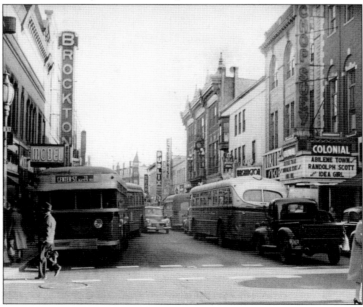

Appearing more like midtown Manhattan than Brockton, this post–World War II view of Main Street looking south from about East Elm Street shows a street crowded with cars, trucks, busses, and people. Playing at the Colonial Theater was Abilene Town, featuring Randolph Scott and Lloyd Bridges. The church-like spire of the Belmont Hotel can be seen in the distant center of the picture. (Courtesy of the Brockton Historical Society Fire Museum.)

NOMINATE AND ELECT

EX-ALDERMAN
CHARLES J.

HELANDER

FOR ALDERMAN

WARD SEVEN

Four Years in Common Council.
Two Years in Board of Aldermen.
President of Board of Aldermen—1929.

GEORGE D. HARRIMAN,
56 Hillcrest Avenue.

Many immigrants took an active role in public service; among them were Swedish immigrants Charles J. Helander, a shoe factory worker, and Albin F. Nordbeck, a self-employed builder. Helander served several years on the Common Council and Board of Adlermen, the forerunner to today's city council. Nordbeck also served on both the Common Council and Board of Aldermen as well as the sewer commission and went on to represent the city in the Massachusetts House of Representatives. Most Swedes of the time were Republican in party affiliation, and Nordbeck served as president of the city's Scandinavian Republican Club. (Below, courtesy of the Brockton Historical Society Fire Museum.)

REMEMBER

That your duty, as a good citizen, is to go to the polls and cast your ballot on election day.

VOTE TO ELECT

ALBIN F. NORDBECK

Who will honestly, ably and faithfully represent you in the Legislature.

YOUR POLLING PLACE IS

Ward 4, Precinct B, Franklin Hall

Election Day, Nov. 3rd

REPUBLICAN CANDIDATE
FOR REPRESENTATIVE, NINTH DISTRICT

COMMITTEE.

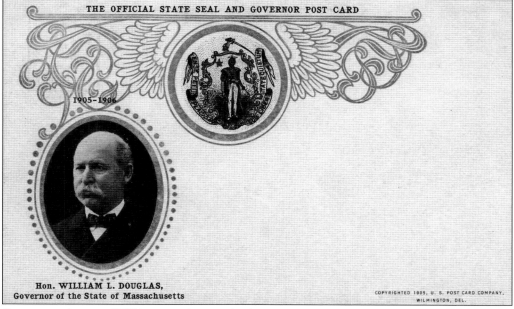

VOTE FOR
ALBERT G. (DAN) SMITH
CANDIDATE FOR
DEMOCRATIC NOMINATION FOR
MAYOR
Caucuses, Thursday, Nov. 16, 1916
AT 7.30 P. M.

His vote getting ability was proven last year.

YOUR Vote at the Caucuses may mean his election.

CHAS. M. HICKEY, 12 Doris Ave.

Not all candidates were successful in the run for office. In 1916, Albert G. "Dan" Smith ran for the Democratic nomination for mayor. John Burbank became the city's mayor that year. Postcards such as this became standard campaign fare, and all bore the "union bug," indicating it was printed in a union shop. On this card that "bug" appears at the lower left. Smith was the founder of the Albert G. Smith & Sons insurance company, which is today part of the Smith, Buckley & Hunt agency.

THE OFFICIAL STATE SEAL AND GOVERNOR POST CARD

1905-1906

Hon. WILLIAM L. DOUGLAS,
Governor of the State of Massachusetts

COPYRIGHTED 1905, U. S. POST CARD COMPANY,
WILMINGTON, DEL.

Shoe manufacturer William Lewis Douglas became governor of Massachusetts in 1905 and served a one-year term. A Democrat, Douglas served two terms in the Massachusetts House of Representatives, one term in the state senate, and served as Brockton's mayor in 1890. As governor, Douglas established the Douglas Commission to determine how education could be reformed to create a better workforce. A leper colony was also established at Penikese Island during his term.

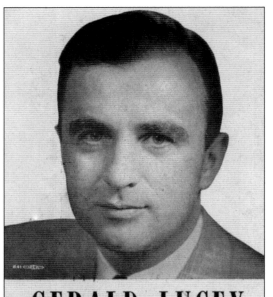

In 1952, two-time Brockton mayor C. Gerald Lucey ran for lieutenant governor of Massachusetts. A former member of the State House of Representatives, Lucey lost the primary election. Lucey is credited with attracting the Veterans Administration Medical Center to Brockton and with constructing four junior high schools during his four years as mayor. Lucey, uncle to the current (2013) state representative Claire Cronin, died in 1989.

GERALD LUCEY

Mayor of Brockton

Our Next

Lieutenant Governor

This 1969 campaign postcard heralds Robert A. Kane's run for a city council seat, representing Ward No. 1. Kane, an accountant with the Brockton Edison Company, was a graduate of Brockton High School and was active in Our Lady of Lourdes parish. He was also one of the foremost authorities on Brockton history, especially that of the city's Irish, and wrote several volumes and numerous articles about Brockton's history.

VOTERS OF WARD 1
Elect
Robert A.
KANE
Your
COUNCILLOR

ELECTION DAY, NOV. 4, 1969
FOR TRANSPORTATION CALL 587-9783

 8 (over)

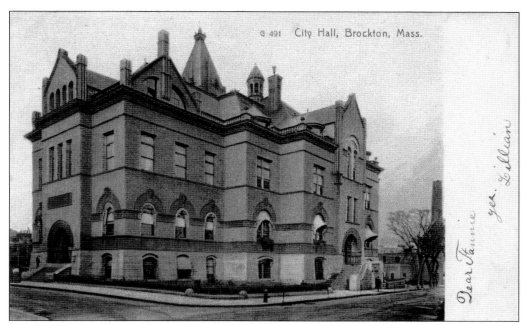

Dedicated in 1894, Brockton's city hall on School Street was an ostentatious showing that Brockton had come into its own economically by the late 19th century and needed a public building worthy of its stature as one of the leading centers of shoe manufacturing in the world. Designed by Brockton architect Wesley Lyng Minor, this building was also designated to serve as a memorial to the city's Civil War dead. Today, all of Brockton's war dead are honored in the memorial corridor surrounded by paintings of the Civil War by Richard Holland, F. Mortimer Lamb, and Isaac W.F. Eaton. The 13 firefighters who died in the Strand Theater fire on March 10, 1941, are honored in the rotunda. The surrounding neighborhood, such as that seen to the left in the postcard below, is gone, and a housing complex has taken its place.

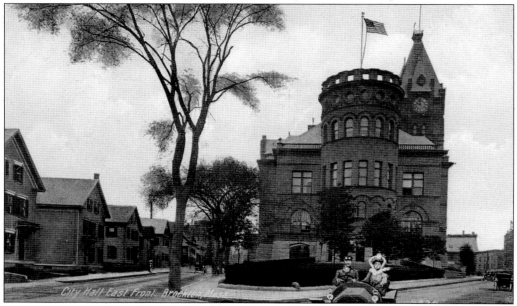

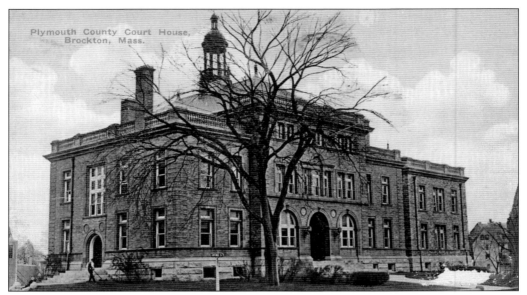

These two views show the Plymouth County Superior Courthouse, located at the corner of Belmont Street and Warren Avenue. This Renaissance Revival building was constructed in 1891 and was designed by John Williams Beal. The building was constructed by well-known Brockton contractor George Howard, whose son Harry C. Howard would serve as mayor in 1911–1912. Harry Howard would be among the Brocktonians to die in a boating accident on Moosehead Lake in Maine in May 1928. The cupola and some of the ornamentation is gone from the building today, but it retains Beal's classic design. This building continues to serve Plymouth County's court system. Among Beal's most famous works was Lucknow, the home he designed for Roxbury, Massachusetts, shoe manufacturer Thomas Gustave Plant in Moultonborough, New Hampshire, and is today known as the Castle in the Clouds.

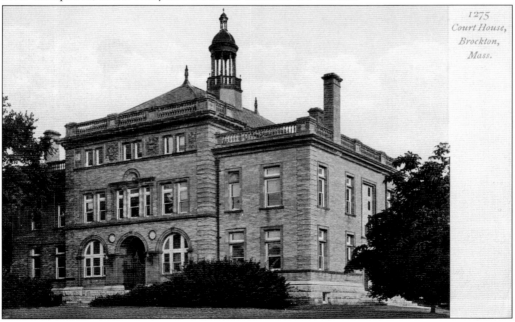

Six

RECREATION

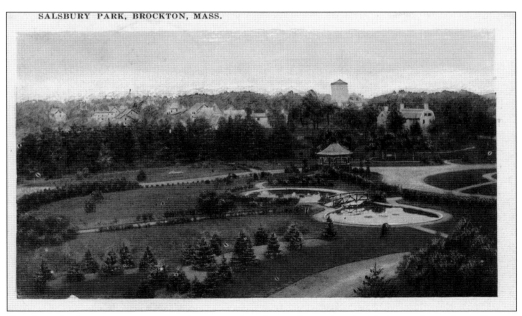

SALSBURY PARK, BROCKTON, MASS.

Brockton had many great venues for recreation throughout the city. Among the early parks was Salisbury Park, pictured here on the city's east side near the site where Chandler Sprague had his Factory Village. This area was once vital to manufacturing because of its waterpower with the Salisbury and Trout Brooks converging here. (Courtesy of the Brockton Historical Society Fire Museum.)

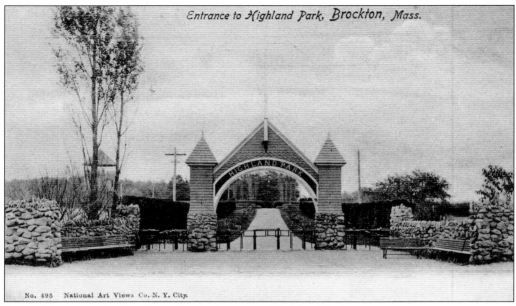

Entrance to Highland Park, Brockton, Mass.

No. 495 National Art Views Co. N. Y. City.

Located just over the Brockton line in Avon was Highland Park, a seven-acre amusement park established by the Brockton Street Railway to increase ridership and revenue. The park opened on August 11, 1892. Featuring scenic walkways, rockeries, footbridges, and elegant gardens, the park also contained concession stands, a restaurant, a bandstand, and dance pavilion. A baseball diamond was constructed at the park and was used for many years by the Brockton Shoemakers. The attractive arched entrance is shown above, while a peaceful springhouse would attract city dwellers to the park pictured below. Highland Park also had a merry-go-round and a roller coaster. On August 30, 1898, it was reported that 14,000 people attended the annual picnic and outing of the Old Stoughton Musical Society at 5¢ a head for a trolley ticket to the park—the railway made out handsomely.

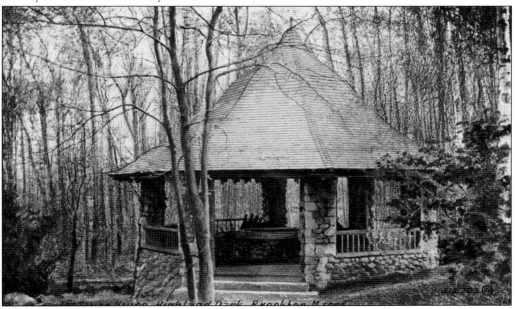

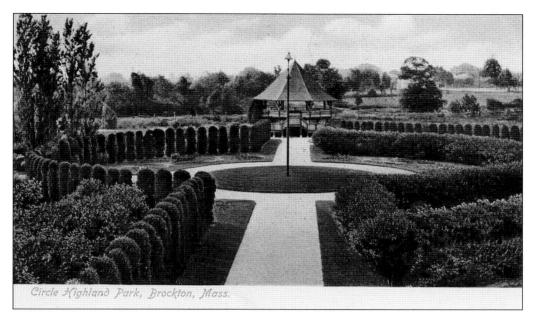

Circle Highland Park, Brockton, Mass.

Highland Park boasted elegant walkways and gardens, as pictured above, while below, an observation tower 57 feet in height provided visitors views of the Blue Hills to the north. One famous visitor to the park was the "Kansas Smasher" prohibitionist Carry A. Nation. On September 8, 1902, she spoke before 5,700 people, mostly women, about the evils of the devil, liquor, cigarettes, and the Republican party. She referenced US president Theodore Roosevelt by referring to him as the "German beer-swigging" man in the White House. As the trolleys disappeared, so did Highland Park, and in 1954, the town of Avon gave approval for 27 housing units to be constructed on the site.

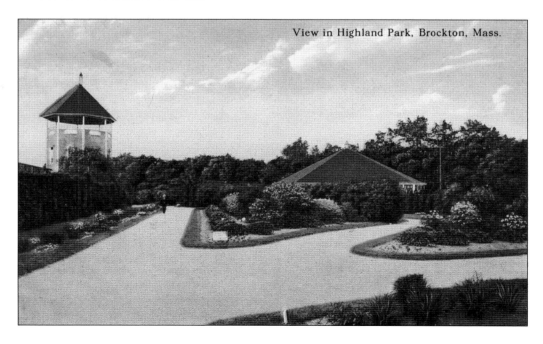

View in Highland Park, Brockton, Mass.

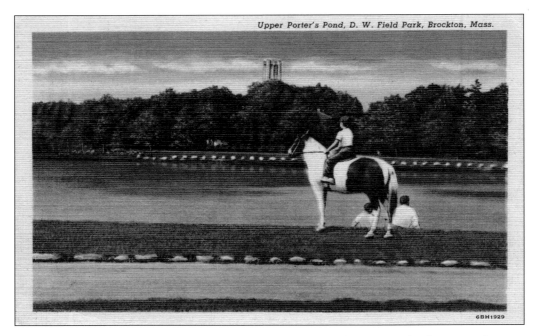

Upper Porter's Pond, D. W. Field Park, Brockton, Mass.

6BH1929

These two idyllic scenes are of Brockton's D.W. Field Park, a gift to the city by shoe manufacturer, farmer, environmentalist, and philanthropist Daniel Waldo Field in 1925. Consisting of 756 acres, this park is off Oak Street and stretches to the Avon line in the north. The construction and development of this park was overseen by Field personally. The observation tower pictured below rises from the highest point in the park and stands almost in its center. The hill on the backside of the tower leads to the D.W. Field Golf Course and has been a favorite sledding hill for generations of young Brocktonians.

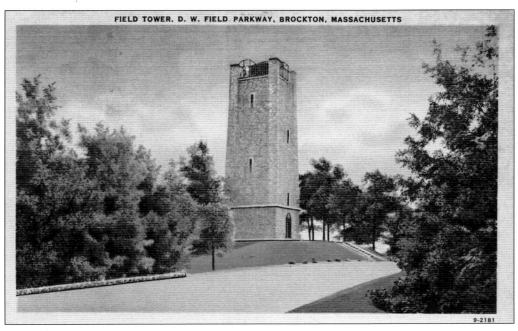

FIELD TOWER. D. W. FIELD PARKWAY, BROCKTON, MASSACHUSETTS

9-2181

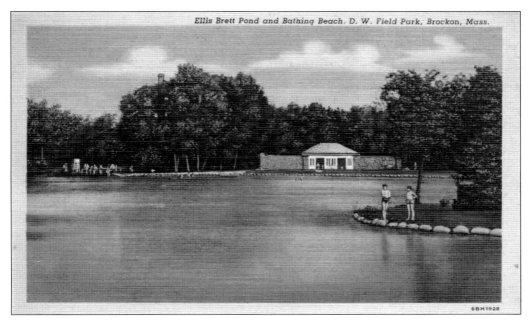

Ellis Brett Pond and Bathing Beach, D. W. Field Park, Brockon, Mass.

Daniel Field wanted his park to be used for recreation, and the many ponds were used for swimming and fishing. Pictured in these two postcards is the bathhouse at Ellis Brett Pond, one of the region's most-famous swimming holes. When first constructed, several buildings dotted the landscape, including a log cabin similar to one that Field had seen on a trip to a Maine logging camp and a wigwam, which was 32 feet in height and 18 feet across. In the few buildings erected in the park, Field only allowed candlelight, saying that Eden did not have electric lights—then again, it probably did not have candles either.

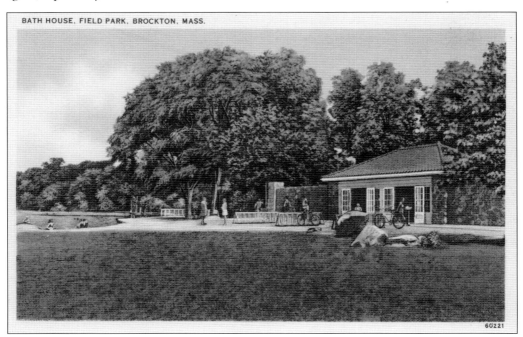

BATH HOUSE, FIELD PARK, BROCKTON, MASS.

Waldo Lake in D. W. Field Park, Brockton, Mass.

Water is central to the design of many parklands, and Field's design was no different. The walking trails and road system of the park all wend their way along the various waterways. The falls pictured in the scene below have been the site of many weddings and wedding photographs over the park's lifetime. Field was a park commissioner in Brockton, and in 1908, when the city purchased land for 13 playgrounds, Field personally oversaw their development and covered much of the cost. When he constructed the golf course at Field Park, he foresaw an income stream for the city, and when some naysayers questioned him, he said if the city did not want it, he would buy the gift he gave them back for $200,000.

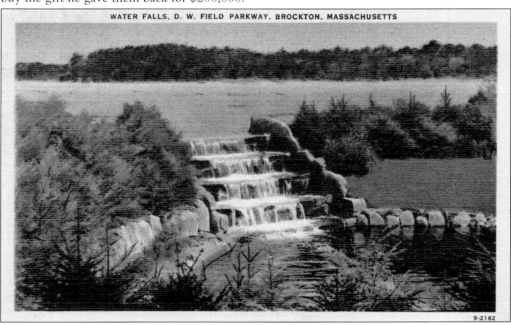

WATER FALLS, D. W. FIELD PARKWAY, BROCKTON, MASSACHUSETTS

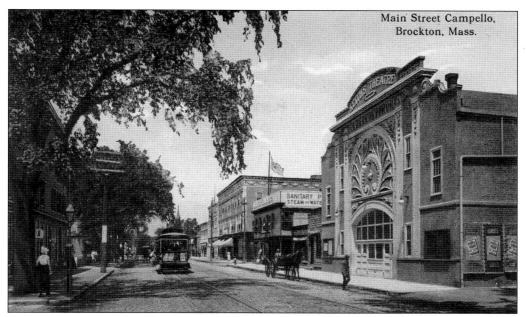

Movie houses were a vital aspect of recreation in the city. The Keith Theater stood on Main Street in the Campello section of the city, close to where Deftos Liquor store is located today. Keith's began as a vaudeville house and was eventually converted into a movie house. The theater had a total of 790 seats. For many years, Keith's showed films in Swedish, catering to the Swedish population in the neighborhood.

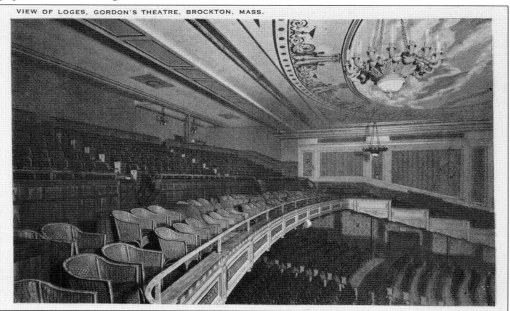

Another of Brockton's popular movie houses and perhaps the largest was Gordon's Olympia Theater with a seating capacity of 2,500. Gordon's was part of a chain of theaters owned by Russian immigrant Nathan Harry Gordon, who, with his brothers, began an empire with a nickelodeon machine in Worcester, Massachusetts, in 1906.

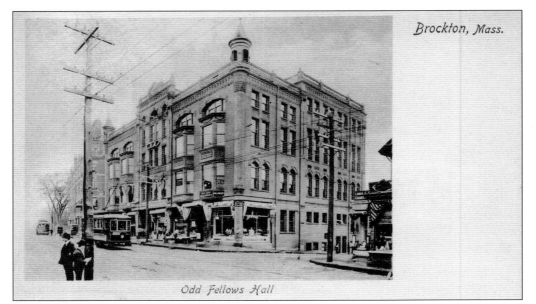

Brockton, Mass.

Odd Fellows Hall

The Whipple-Freeman Building stood on the east side of Main Street between Franklin and Court Streets. Erected by John J. Whipple, who was a druggist and at one time mayor, the building with its Moorish-style turrets was home to the local lodge of the Independent Order of Odd Fellows as well as several offices and businesses. This building was lost to urban renewal in 1965.

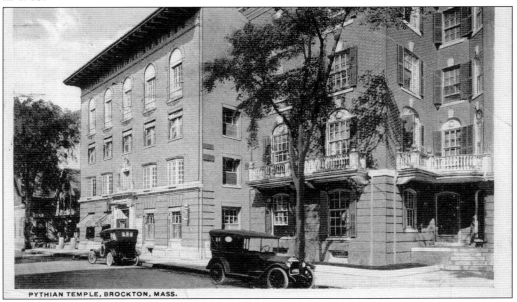

PYTHIAN TEMPLE, BROCKTON, MASS.

Located on West Elm Street, the Pythian Temple was an elegantly designed building, found adjacent to the Central Methodist Church. Designed by James H. Ritchie, the building consisted of four floors: a basement containing a banquet hall, a first floor with a dance hall and stage, and the second floor, extending two stories up, held a card room, poolroom, and offices, while the fourth had a lodge room and meeting rooms. The building suffered major fire damage as a rooming house and today stands vacant.

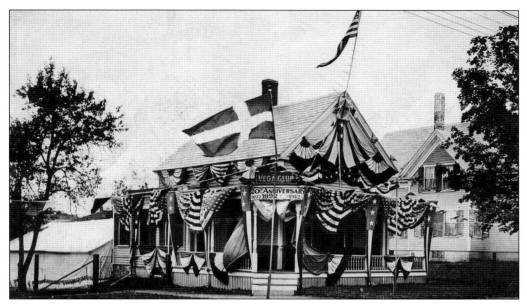

Named for the Swedish ship *Vega* that was the first to complete the Northwest Passage in 1878–1879, the Vega Club was established on September 11, 1892, and was organized by Swedish immigrants for the purpose of "profit and pleasure." The house pictured here is festooned in celebration of the club's 20th anniversary in 1912. This house stood at the corner of Warren Avenue and Nilsson Streets, where the 1920s clubhouse now stands.

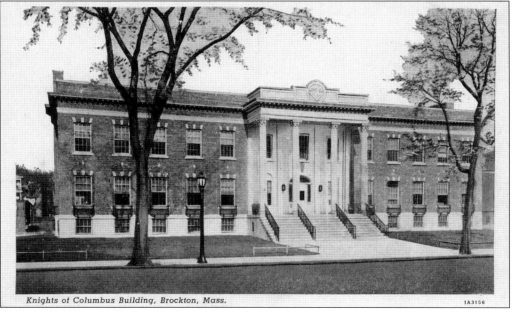

Knights of Columbus Building, Brockton, Mass.

The Brockton Knights of Columbus were established in 1920, and in 1929, the building pictured here was erected at a cost of $91,929. The brick building had 16,065 square feet of floor space, including four bowling alleys, pool and billiard room, lounge, and a second-floor hall. In 1973, the building was demolished to make room for parking for the district courthouse. (Courtesy of the Brockton Historical Society Fire Museum.)

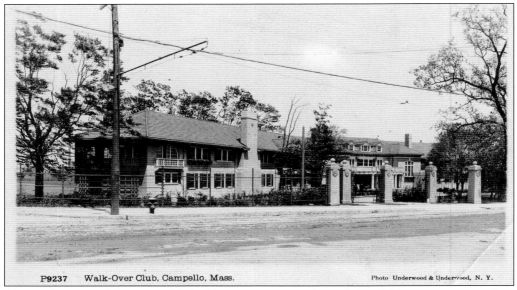

P9237 Walk-Over Club, Campello, Mass. Photo Underwood & Underwood, N. Y.

The Walk-Over Club was established by George E. Keith, and this clubhouse was erected on Perkins Avenue for the benefit of the company's employees. Membership in the club was open to all Keith employees. The club was set on 13 acres of land and included a baseball field, squash courts, tennis courts, and bowling alleys. Classes were offered in everything from sewing to dancing. Annual field days were held for employees, and Walk-Over documents indicate the event attracted more than 15,000 people in 1920. Keith was known as a leader in providing workplace benefits for his workers, such as an in-factory infirmary as well as a cafeteria. The Walk-Over Club sat vacant for many years and was eventually torn down; an apartment complex was built in its place, which retained some architectural features of the old building and was named Walkover Commons.

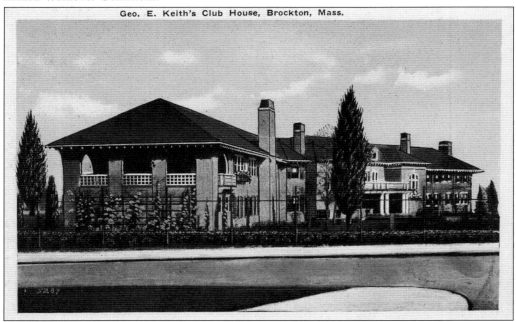

Geo. E. Keith's Club House, Brockton, Mass.

Seven

INDUSTRY AND COMMERCE

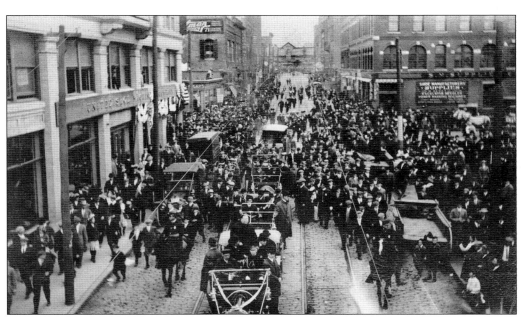

A little over 100 years ago, Brockton had come into its own as a center of national, if not world, prominence. As one of the largest production centers of men's and boys' boots and shoes in the world, the city drew many ancillary businesses to the region and attracted the attention of national leaders such as Pres. William Howard Taft, shown here in his motorcade down Centre Street on October 3, 1912.

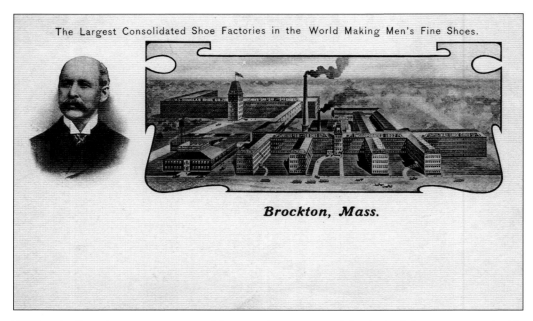

The Largest Consolidated Shoe Factories in the World Making Men's Fine Shoes.

Brockton, Mass.

William L. Douglas was a master at self-promotion; it was said that he had the most recognizable face in the world as a result of his advertising—all of which contained his likeness. These two postcards show his face as well as his sprawling factory complex, located on the north end of the city. Douglas's face even appeared embossed into the soles of his shoes. As the legend on the card below proclaims, his factory was the largest in the world under one roof producing men's and boys' shoes. Douglas was among the first shoe manufacturers to set a retail price at the factory and was famous for his $3 shoe. Douglas's factory eventually became home to the Knapp Shoe Company, and today, virtually nothing of this massive complex remains.

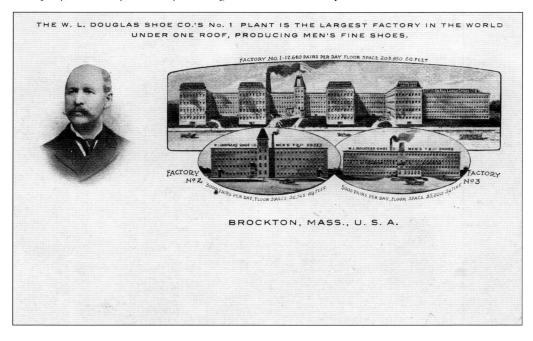

THE W. L. DOUGLAS SHOE CO.'S No. 1 PLANT IS THE LARGEST FACTORY IN THE WORLD UNDER ONE ROOF, PRODUCING MEN'S FINE SHOES.

BROCKTON, MASS., U. S. A.

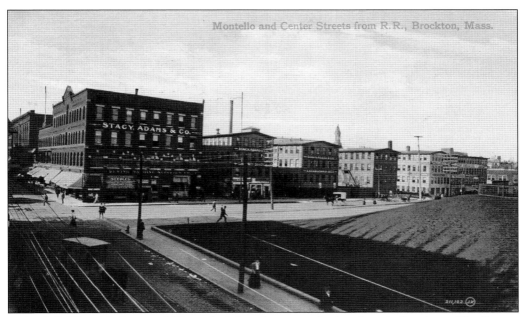

In 1875, William H. Stacy and Henry L. Adams began producing shoes in Brockton. The factory buildings of this company stood like sentinels along Montello Street, opposite the station of the Old Colony Railroad. Located at the corner of the factory site was the stately Gardner Building, shown in the postcard below. The Gardner Building held many retail businesses on the street level and office space on the upper floors. After several attempts to save this remnant of Brockton's history, the Gardner Building was demolished in early 2013. Shoes are still produced under the Stacy Adams name today, and the company lists "Brockton Originals," which are classic designs taken from the original patterns of this iconic Brockton brand, in its collection.

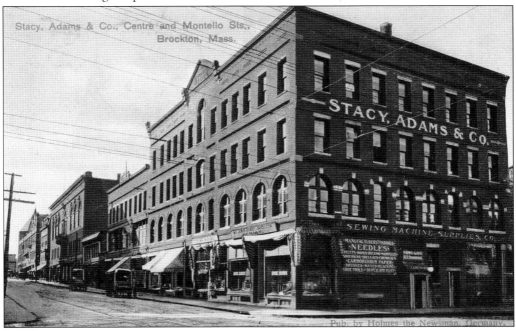

83

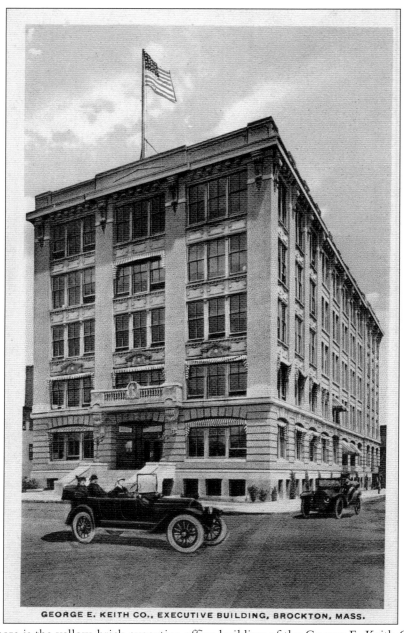

GEORGE E. KEITH CO., EXECUTIVE BUILDING, BROCKTON, MASS.

Pictured here is the yellow-brick executive office building of the George E. Keith Company, which was located on Station Avenue in the heart of the Walk-Over manufacturing complex in Campello. This five-story building was opened on January 31, 1911. Considered fireproof and constructed of brick, steel, and concrete, this building was state of the art and the finest of its kind in the shoe trade. The fifth floor contained a banquet hall as well as a kitchen and several pantries. The offices of George E. Keith and his executives were said to have been of the finest design and paneled in oak. The basement of the building contained bowling alleys and a gymnasium for employee use. Regrettably, after years of standing as a vacant symbol of Brockton's past greatness in the shoe industry, the building was torn down just short of its 100th year.

Geo. E. Keith Company,
Shoe Manufacturers.

Campello, Mass., *10/19* 189

Your special order given *10/6* is
at hand and we are pleased to accept the same.
Will give it our prompt attention. Awaiting
your further favors, believe us,

Yours respectfully,

Geo. E. Keith Company.

Per *E. A.*

SHIPPED

"PENNSY."

The earliest known postcard mailed in the United States was sent in 1848 and contained advertising. It was not until 1873 that postcards began being commercially published and were designed to be a way to send a quick note. Companies such as the George E. Keith Company soon realized that postcards were an effective way to communicate with customers, as is shown by this card confirming an order.

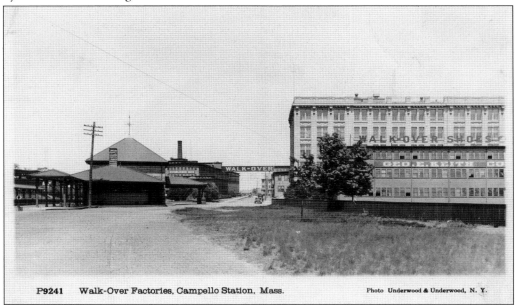

P9241 Walk-Over Factories, Campello Station, Mass. Photo Underwood & Underwood, N. Y.

This view shows the executive building of the George E. Keith Company dominating older factory structures and the Campello railroad station. Note the bridge spanning Station Avenue that connects two factory buildings and is emblazoned with the Walk-Over name. The close proximity of the rail station was of great benefit to the George E. Keith Company, making it easy for visitors from around the world to visit the factory. (Courtesy of the Brockton Historical Society Fire Museum.)

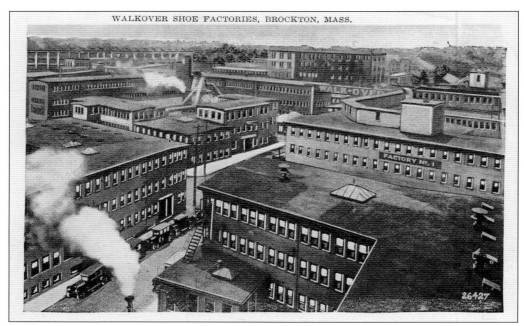

The above postcard shows the sprawling factories of the George E. Keith Company that were located off Perkins Avenue in the Campello section of the city. With the shoe giant Douglas at the city's north end and Keith in the south, these two companies became known as the bookends of the city. Most of Brockton's shoe factories were similar in basic design and of wood-frame construction. These early factories relied on heavy fenestration to allow natural light into the work area. As time went on and construction methods changed, large glass-and-concrete factory buildings, such as that pictured below, replaced many of the wooden factory structures. A couple of these concrete structures still occupy the Keith site and are used by other industries today.

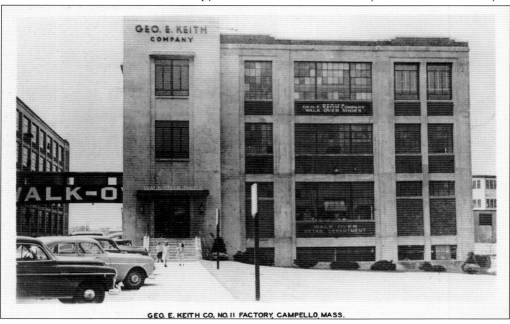

GEO. E. KEITH CO. NO. 11 FACTORY, CAMPELLO, MASS.

HOME OF THE FAMOUS RALSTON HEALTH SHOE, CAMPELLO MASS.

Among the landmarks in Campello was the sprawling shoe factory of Churchill and Alden. Formerly the Copeland factory, it was taken over by George Churchill and Lucius Alden in 1889, and in 1899, they launched the Ralston Health Shoe brand. The brand touted among its many patented improvements in shoe design a waterproof sole. After the demise of Churchill and Alden, this factory became the home to London Clothing and would eventually succumb to a massive fire.

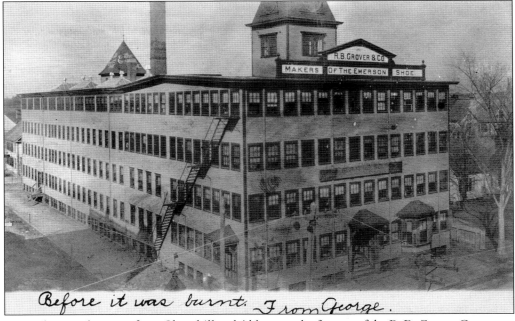

Located across the street from Churchill and Alden was the factory of the R.B. Grover Company, makers of the Emerson shoe brand. This postcard shows the factory before the tragic boiler explosion of 1905. This company was typical of the time where the names of the owners would be used in various ways. In this case, Robbins B. Grover and Charles O. Emerson were both principals in the operation, but Grover's name was used on the factory while Emerson's was used for the shoe brand.

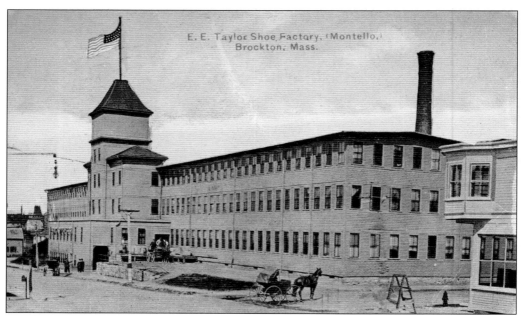

The E.E. Taylor Company was founded by Edward E. Taylor and George M. Peabody, and the factory was located on Bellevue Avenue. During World War I, Taylor contracted to produce 1.75 million pairs of 18-inch boots. Worth $16 million, the contract required 2,000 workers working around the clock to meet the deadline. In 1937, the company moved to Augusta, Maine, and in 1939, Knapp Shoe absorbed the company. This factory was torn down in 1983.

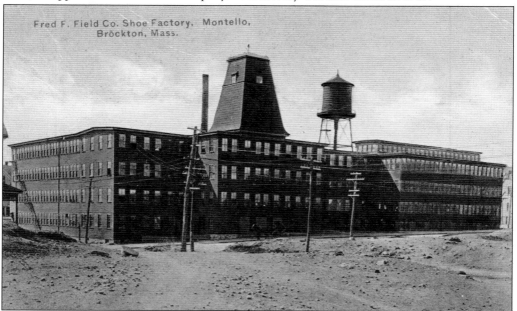

Beginning his career in the shoe industry with the Burt and Packard Company, Frederic Forrest Field soon became a partner, and the firm's name was changed to Packard and Field. This company was among the first to use phonetics in advertising with their 'Korrect Shape" brand. Field also owned the Fred F. Field Company, shown here with its distinctive tapered tower.

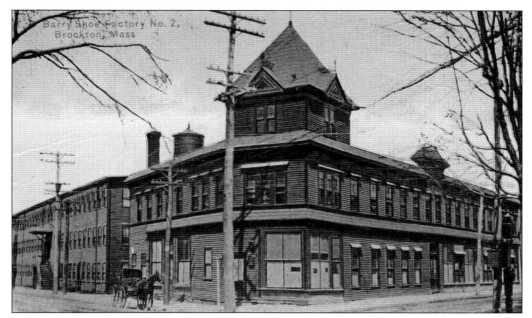

In 1888, Thomas D. Barry began making shoes in Brockton and partnered with his brother-in-law William A. Hogan. In his first year, he produced $25,000 worth of shoes and by 1897 was at $600,000. When he died at the age of 49 in 1911, all of the city's factories were silenced for five minutes in tribute. This factory later became home to the Doyle Shoe Company.

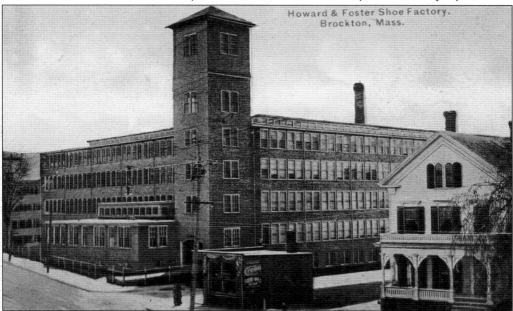

In 1887, Charles Howard and Charles H. Foster began manufacturing shoes in a factory located at Montello and Ward Streets, and in 1906, they erected this large factory complex at 160 Pleasant Street at the corner of Warren Avenue, directly across from the Barry factory. Howard was one of the founders of the Brockton Agricultural Society and president of its Brockton Fair for many years.

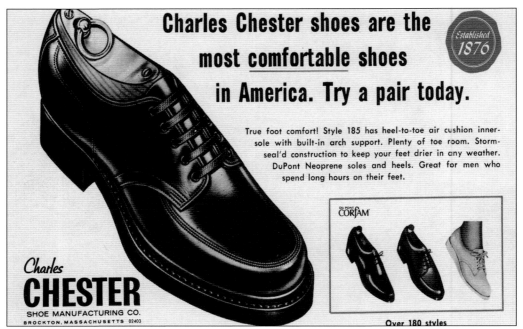

Charles Chester, named for company president Charles Chester Eaton, was a brand of the Charles A. Eaton Company. Eaton developed a program for sales where an individual could become a representative of the company, take orders, and collect a deposit, and the factory would do the rest. The company even offered a trade-in program to get consumers to try their shoes. This company operated on Foundry Street.

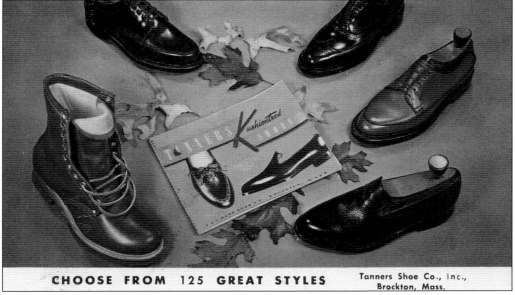

Here, this Tanners Shoe Company postcard boasts 125 styles to choose from. In the 1960s, this shoe store was located on Forest Street in the Campello section of the city and was operated by Manuel Alter, Bernard Lazarus, and Arthur Alexander. These three men also owned King Size, Inc., at the same location.

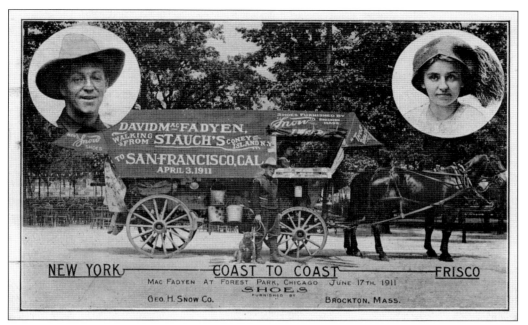

On April 3, 1911, David MacFayden and his wife left Stauch's Restaurant at Coney Island, New York, on a walking trip cross-country to San Francisco. Travelling in this wagon, the MacFaydens arrived in Chicago on June 17, 1911, where this postcard image was photographed. MacFayden was wearing shoes made by the George Snow Company of Brockton and proudly advertised the company on his wagon.

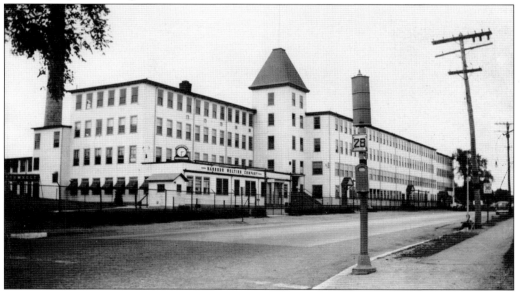

Pictured here is the Barbour Welting Company on North Montello Street just north of Howard Street. This factory produced the welt that was used in joining the shoe upper to the inner sole. Barbour began in business in 1892 and continues to produce shoe welting, among other products, in a modern factory across the street from this location. The site of this factory is a grocery store today. (Courtesy of the Brockton Historical Society Fire Museum.)

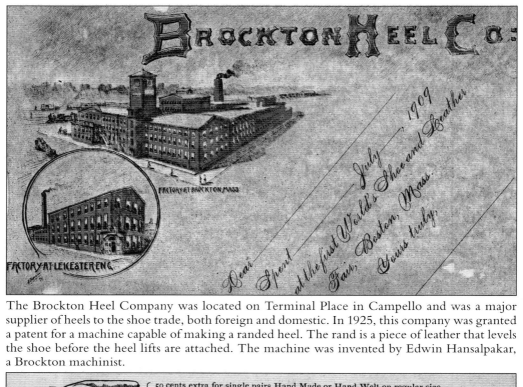

The Brockton Heel Company was located on Terminal Place in Campello and was a major supplier of heels to the shoe trade, both foreign and domestic. In 1925, this company was granted a patent for a machine capable of making a randed heel. The rand is a piece of leather that levels the shoe before the heel lifts are attached. The machine was invented by Edwin Hansalpakar, a Brockton machinist.

50 cents extra for single pairs Hand Made or Hand Welt on regular size.
25 cents extra for single pairs Burtwelt on regular size.
$1.00 extra for shoes made to measure or on a last altered in any way from regular size.
We work exactly to measure sent us and never make allowances or alterations.
We are not responsible for misfits on measures.

IN ORDERING DUPLICATES PLEASE SEND CASE NUMBERS.

Brockton, Mass., 4/22 1896.

THE BURT & PACKARD
"Korrect Shape"

Gents: Your order of the 20th, for

................ 1 pairs is at hand and will receive prompt

attention ..

Yours respectfully, Packard & Field.

Makers of the BURT & PACKARD "KORRECT SHAPE" SHOE.

Your order is making. No countermands accepted after the above date.

In the late 1890s, orders were being confirmed via preprinted postcards that only required an office worker to fill in a minimum of information. The card spells out various rules of the factory as they pertain to the order and are much in line with ordering and returning procedures still used today on custom products. Note the cut-away imprint of the shoe exposing the toes of the wearer to indicate how well the shoe fits.

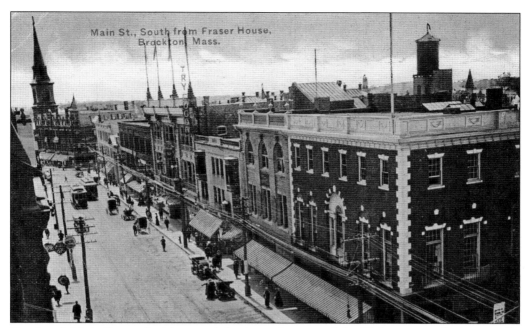

Brockton's Main Street, looking south in the early years of the 20th century, depicts a well-ordered, modern city with well-constructed, fanciful buildings. In the foreground with its awnings extended is the dry goods store of James Dyce, while farther down the street are the flag-topped turrets of James Edgar's Boston Store. Note in the distance the steeple of St. Patrick's Roman Catholic Church.

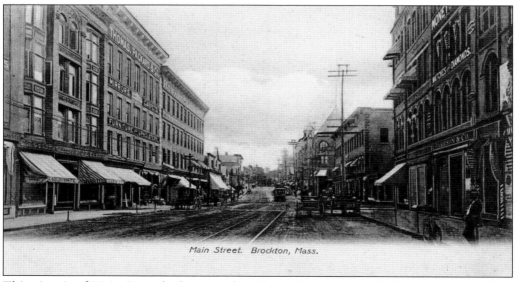

This view is of Main Street looking north with the distinctive roof of the Bryant Building on the right. Note the extreme height of the electric pole, indicative that Edison's three-wire underground system did not stay underground very long. This view of Main Street is treeless, although one of the reasons for Edison's underground system was to preserve tree-lined streets in the 1880s.

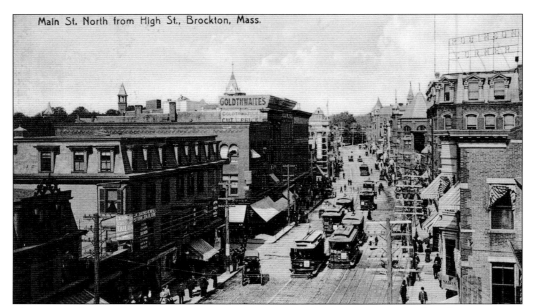

This postcard view of Main Street portrays as many as 10 streetcars traversing its length. Downtown Brockton was the mercantile center of the region, offering a host of retail establishments, restaurants, and theaters. In addition, the upper floors of many of these buildings were occupied by doctors, dentists, and attorneys. The tall building on the left with the sign atop its roof is the Bixby Block at the corner of School Street.

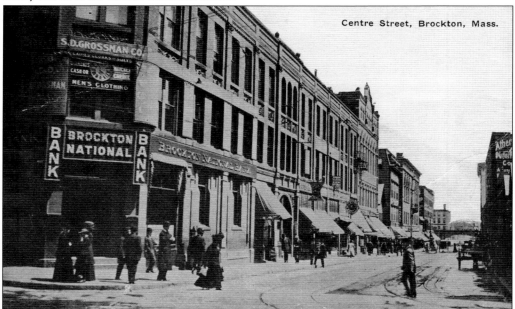

Centre Street, Brockton, Mass.

Centre Street, between Main and Montello Streets, was a virtual canyon of commerce, as shown in this postcard view. The Brockton Savings Bank dominated the Main Street corner while the Joslyn and Gardner Blocks appear on the north side—all of these buildings are gone today. The area is undergoing major revitalization. In the distance can be seen the Centre Street viaduct, which carried the railroad over the roadway.

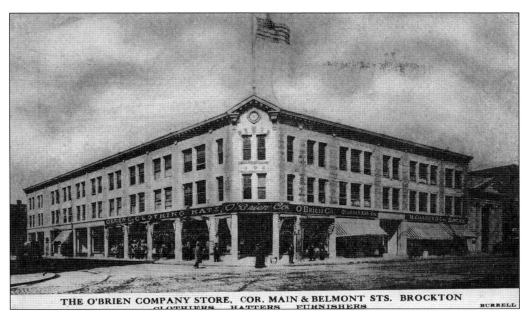

THE O'BRIEN COMPANY STORE, COR. MAIN & BELMONT STS. BROCKTON
CLOTHIERS HATTERS FURNISHERS BURRELL

Erected in 1908, Barrister's Hall sits on the northwest corner of Main and Belmont Streets. This building was designed by John Williams Beal and employed the latest in construction technology of the day, the Roebling Fireproof System. This system, designed by the firm that constructed the Brooklyn Bridge, made the building virtually free from the danger of fire. This building was once home to Sears, Roebuck and Co.

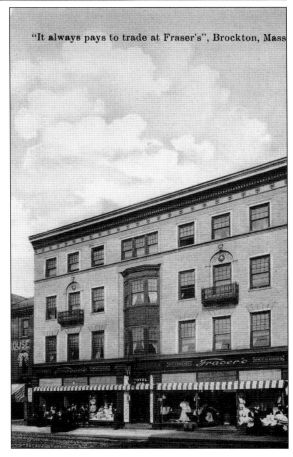

"It always pays to trade at Fraser's", Brockton, Mass

Fraser's Department store was a locally owned and operated department store and a Main Street icon for decades. The store's one-time motto was the following: "The Store of Service offering you the lowest prices, the latest styles, and the most courteous service." Stores of this kind, and downtown in general, suffered major decline when Westgate Mall opened in 1963 as one of the first enclosed malls in the state.

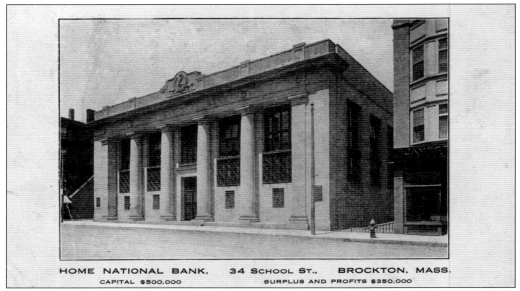

HOME NATIONAL BANK, 34 School St., BROCKTON, MASS.
CAPITAL $500,000 SURPLUS AND PROFITS $350,000

Another Brockton building designed by John Williams Beal was the Home National Bank, located at 34 School Street. Erected in 1911, this bank received a federal charter in 1874, and among its directors over time were many of Brockton shoe manufacturers, including William L. Douglas and Preston B. Keith. The bank eventually became Plymouth Home National Bank and then Bank of New England. Today, the building is occupied by several different tenants.

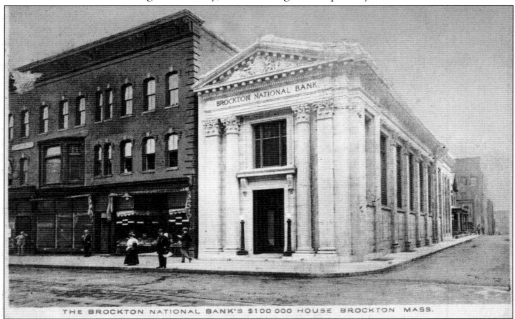

THE BROCKTON NATIONAL BANK'S $100 000 HOUSE BROCKTON MASS.

The Brockton National Bank was chartered in 1881, and this handsome columned structure was erected at the corner of Main and Church Streets in 1913. Many prominent Brockton businessmen were among the bank's founders, including Ziba C. Keith, George E. Keith, Davis S. Packard, John J. Whipple, and others. This was another city building lost to urban renewal; however, the carved pediment, which portrays the city's symbol, is today preserved at City Hall Plaza.

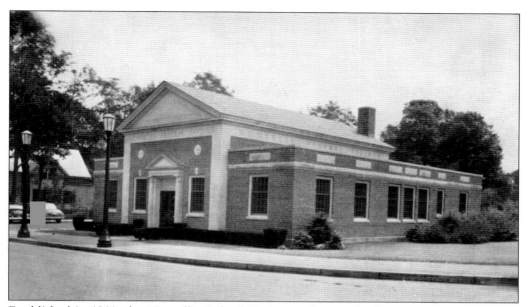

Established in 1911, the Montello Federal Savings and Loan Bank occupied this lot at the intersection of North Main and Oak Streets. The home that can be seen in the left of the picture is that of Daniel Waldo Field. The bank closed in 1975, and the property is now a branch office of HarborOne Credit Union. The Field house was razed to expand parking at the facility. (Courtesy of the Brockton Historical Society Fire Museum.)

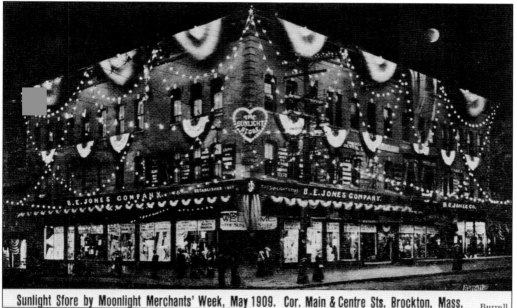

Sunlight Store by Moonlight Merchants' Week, May 1909. Cor. Main & Centre Sts. Brockton, Mass.

This rare nighttime image, taken in 1909, shows the Sunlight Store of Bradford E. Jones and Robert Cook decorated with lights and bunting to promote Merchant's Week in the city. The store, located at the corner of Main and Centre Streets, advertised that there were 19 stores under one roof. Established in 1867, the Sunlight Store was a forerunner of today's department stores and a pioneer in that store type.

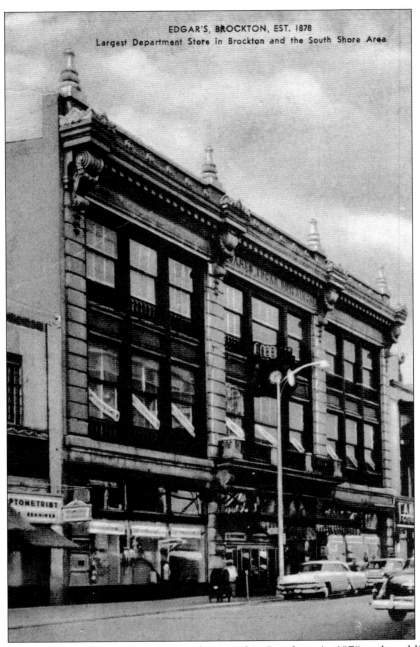

EDGAR'S, BROCKTON, EST. 1878
Largest Department Store in Brockton and the South Shore Area

Col. James Edgar, an emigrant from Scotland, arrived in Brockton in 1878 and established the Boston Store shortly thereafter. Edgar so named his store in an effort to have people associate his mercantile with those fancy establishments located in nearby Boston. A showman, Edgar is credited with being the first department store Santa Claus when, in 1890, he dressed up as the jolly elf to the delight of children and his customers. Edgar dressed up as many different characters and was famous for his annual employee outings and parade. Edgar died in 1909 and is buried in a granite mausoleum at Melrose Cemetery in Brockton. On this site today is the Judge George N. Covett Courthouse.

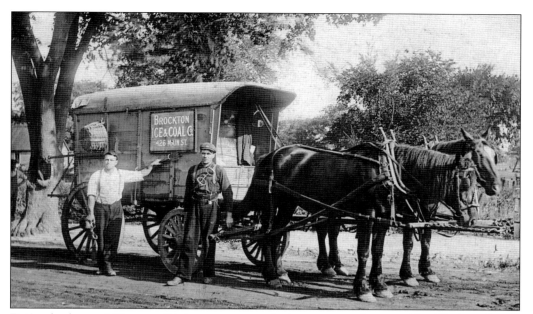

Dating back over 100 years, this image portrays the ice wagon and two unidentified employees of the Brockton Ice and Coal Company. In 1918, Robert White sold the company to Angus Beaton, and the company procured much of its ice from Flagg Pond and the ponds at Field Park. The business continues to this day as the Eastern Ice Company, operated by Joseph and David Rossi, grandsons of Angus Beaton.

This hand-lettered floral postcard was a souvenir card from Carl Mogren, who operated a small store at the corner of Main and East Nilsson Streets. Mogren, a Swede, catered to his fellow countrymen, and his store also included a Swedish lending library. He was also a ticket agent for the Swedish American steamship line.

Brockton. Commercial Club.

384 A CHINESE SPORT. From Painting by Esther Hunt.
Copyright, 1903, by Brown & Bigelow, St. Paul.

A DAILY REMINDER OF

ISAM MITCHELL & CO.
BROCKTON, MASS.

Hardware, Sash, Doors and Blinds

JULY, 1905

SUN	MON	TUE	WED	THR	FRI	SAT
						1
2	3	4	5	6	7	8
9	10	11	12	13	14	15
16	17	18	19	20	21	22
23/30	24/31	25	26	27	28	29

The Commercial Club was a social club organized by and for the businessmen of Brockton and the surrounding towns. Located at the corner of Main and Spring Streets, the organization's facility was designed by P.B. Metcalf and Edward H. Hoyt in 1894; however, sometimes, it is attributed to Wesley Lyng Minor. Today, the elegant facade has been simplified, and the building serves as Father Bill's Mainspring House.

Businesses found postcards to be an inexpensive way to keep their name in front of their customers. This postcard is a Chinese print and a July 1905 calendar from the Isam Mitchell Company, a building materials dealer. A new card would be mailed every month to the company's customers. Establishing his business in 1870, Mitchell would inventory as much as a million board feet of lumber at any one time to meet the demand of the factory construction in the city.

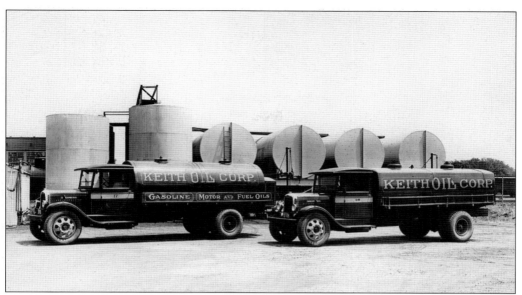

The Keith Oil Company, today's Campello–Keith, was established in 1907. Located on Plain Street in the Campello section of the city, the company continues to serve the city and surrounding area. These two images from the late 1920s and early 1930s show early trucks of the company at the storage facility along the railroad tracks that parallel Plain Street. Also pictured is a rare view of an early tandem tanker. On December 15, 1922, this storage yard was destroyed by a massive fire; the tanks seen in these photographs replaced those destroyed in the blaze. For many years, Brockton had many one-truck independent oil dealers that would buy heating oil at a reduced price from companies such as Keith and then sell it to homeowners. (Both, courtesy of the Brockton Historical Society Fire Museum.)

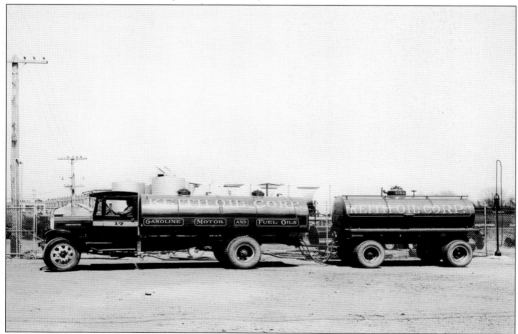

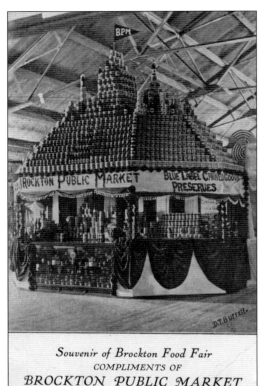

Souvenir of Brockton Food Fair
COMPLIMENTS OF
BROCKTON PUBLIC MARKET

This postcard shows the booth of the Brockton Public Market at the Brockton Food Fair. These fairs, much like home shows and the current Metro-South Chamber of Commerce's event "A Taste of Metro-South," gave merchants the opportunity to showcase their products to the public, hoping to gain customers. This BPM display shows a large array of canned goods as part of the display booth itself. (Courtesy of the Brockton Historical Society Fire Museum.)

This postcard shows workers of the Brockton Public Market parading down Main Street in their annual parade to promote the company. Parades, being an ever-popular event, were often used to promote business. This view was taken directly in front of one of the BPM's competitors, the James A. Dyce Company on Main Street. Unlike today, people would go to a variety of grocery stores to get a certain item from each based on preference.

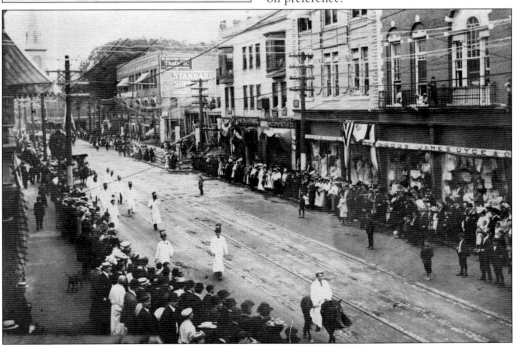

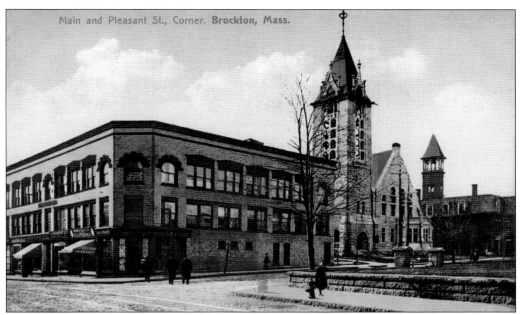

The above postcard shows three of Brockton's historic buildings. In the foreground is the Times Building, which was designed by Wesley Lyng Minor for William L. Douglas in 1897 and was home to Douglas's *Brockton Times* newspaper. Next to the Times Building is the First Parish Church, and next to that is the Central Fire Station. The image below portrays the First Parish Building adjacent to the Times Building. The First Parish Building occupies the space where an earlier edifice of First Parish Church once stood. Occupying the street–level corner of the Times Building in the postcard below was the Wallace drugstore. Today, retail shops still occupy the lower level of the Times Building and elegantly constructed condominiums are in its upper floors. The First Parish Building currently stands vacant.

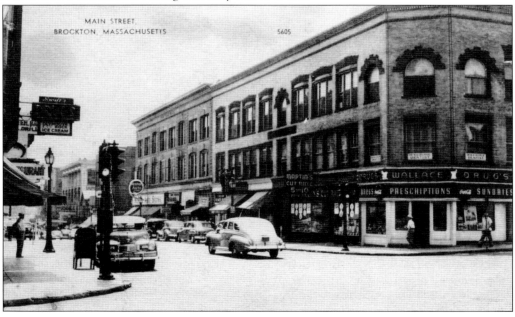

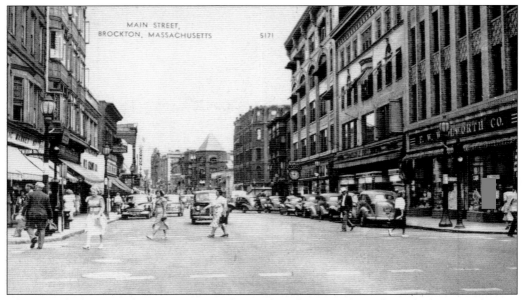

This view looking north up Main Street shows a lot of activity throughout the business district. Postcards like this were printed in the hope that they would be sent to people who would possibly visit Brockton and to show the progressiveness of the city. In an early chamber of commerce brochure, the city boasted 6,000 downtown parking spaces. (Courtesy of the Brockton Historical Society Fire Museum.)

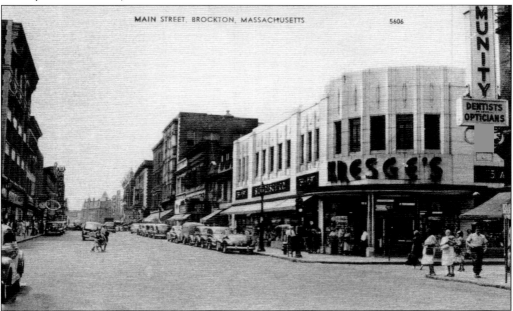

Founded in 1899 by Sebastian S. Kresge, the S.S. Kresge Company was incorporated in 1912 with 85 locations, with one of those being at 173–177 Main Street in Brockton. In 1945, Kresge built a new store at the corner of Main and High Streets, which was easily recognizable by its glazed white building panels. Vacant today, it is hoped that this building can be restored to its postwar brilliance.

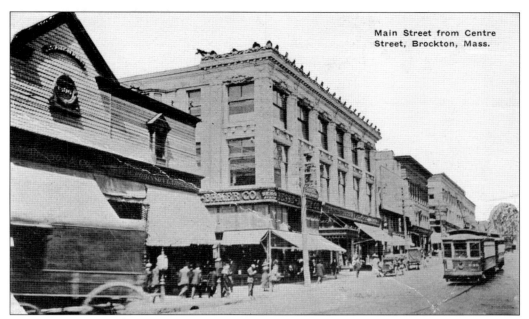

Another of Brockton's well-known clothing retailers was the Besse–Baker Company, located in this formidable building on the west side of Main Street at the corner of what is today Legion Parkway. The wood-frame building is the H.W. Robinson Company, and it sits where Legion Parkway begins today. In 2007, the Neighborhood Health Center erected a medical facility on the site. (Courtesy of the Brockton Historical Society Fire Museum.)

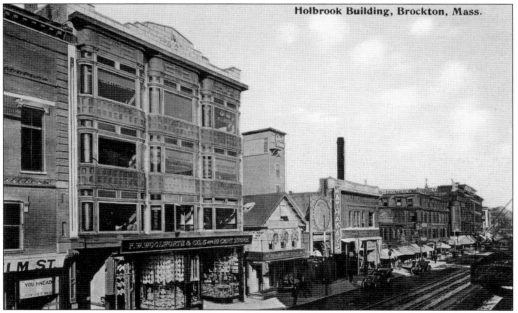

The large building on the left of Main Street is the Holbrook Building, which was destroyed in the Brockton Public Market fire in July 1911. Erected in 1909 at a cost of $100,000 by Susan Cross Holbrook, the building was constructed of brick and wood. Susan Holbrook and her husband, Samuel Adams Holbrook, who died in 1895, owned their own meat and provisions company.

WHERE THE WORLD FAMOUS M.M. MOTORCYCLE IS MADE—BROCKTON, MASS., U.S A.
LARGEST EXCLUSIVE MOTORCYCLE PLANT IN THE WORLD

The large factory of the American Motor Company was located across from where the Brockton Hospital is located on Centre Street and was established by the Marsh brothers to manufacture automobiles. Soon, the brothers ventured off into the world of two-wheeled motorized transportation. In 1899, the Marshes produced a motorized bicycle and in 1904 their first motorcycle. The Marshes made their own engines, which, on the early models, was a one-cylinder, two-horsepower engine. In 1905, the Marsh brothers joined forces with Charles Herman Metz of Waltham, Massachusetts, who was manufacturing motorcycles on his own, and the Marsh-Metz or M.M. brand was born. This postcard proclaims that the company's Brockton facility was the largest exclusive motorcycle plant in the world. Considered among the finest produced bikes of the era, M.M. could not face the growing competition and closed in 1913.

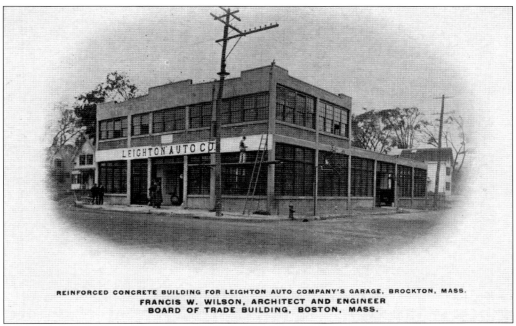

REINFORCED CONCRETE BUILDING FOR LEIGHTON AUTO COMPANY'S GARAGE, BROCKTON, MASS.
FRANCIS W. WILSON, ARCHITECT AND ENGINEER
BOARD OF TRADE BUILDING, BOSTON, MASS.

The Leighton Auto Company was among the first to have a building constructed using the Wilson system of mill and factory construction. This system was designed by Francis W. Wilson, a Boston architect and engineer. The system calls for constructing the building with a concrete frame, wooden floors, and glass walls. This building was constructed at the corner of Warren Avenue and Bartlett Streets in 1908. In 1911, Wilson erected his largest building to that date using this patented technique at the Fore River shipyard in Quincy, Massachusetts. Note the brightness in the card below, which indicates the vast amount of natural light entering the workspace.

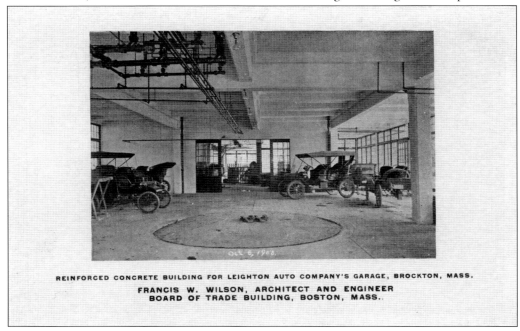

REINFORCED CONCRETE BUILDING FOR LEIGHTON AUTO COMPANY'S GARAGE, BROCKTON, MASS.
FRANCIS W. WILSON, ARCHITECT AND ENGINEER
BOARD OF TRADE BUILDING, BOSTON, MASS.

Most of Brockton's industrial history and record focuses on the giants of industry, and while they did account for the largest economic force in the city, there were many small cottage-type businesses that flourished and provided needed services. One such company was the small sewing machine repair shop operated by Elmer E. Terrio, who was also a shoe worker as was his wife, Flora. Terrio took advantage of postcards to advertise his trade within the community.

This c. 1911 fanciful postcard with its creative message and artwork advertises the Grundstrom and Lawrence furniture store, which was located between the Campello Fire Station and Calmar Street. This store was owned by Charles G. Grundstrom and George C. Lawrence, both residents of Campello.

A. R. PARKER CO.
DAIRY STATION
AT BROCKTON, MASS.
11 High Street

BROCKTON

♦

Parker stand is on site of the livery stable of Edward E. Bennett, early Abolitionist and station agent of Underground Railroad, which "ran" many fugitive slaves safely to Canada.

The A.R. Parker Company was an East Bridgewater–based dairy farm that also had a restaurant and ice cream stands, or, as referred to here, "dairy stations." The dairy had several of these stores throughout southeastern Massachusetts, and each had its own postcard, which gave a note of historical significance. This card notes the abolitionist history associated with its locale on High Street, a stop on the Underground Railroad.

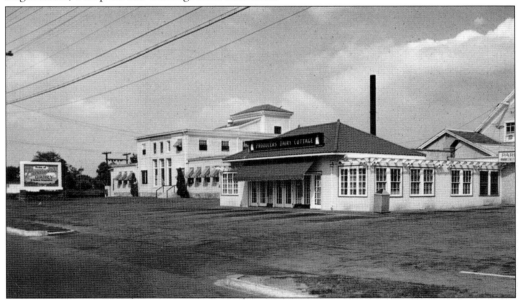

Producers' Dairy was a local cooperative of about 50 dairy farmers who processed and bottled their milk at this plant on Belmont Street. The cream-colored buildings with their red roofs were indicative of the pride and cleanliness of the operation. The single-story attachment was The Cottage, a restaurant frequented by many generations over the years. The dairy's motto was "Particular people prefer Producers'." (Courtesy of the Metro-South Chamber of Commerce.)

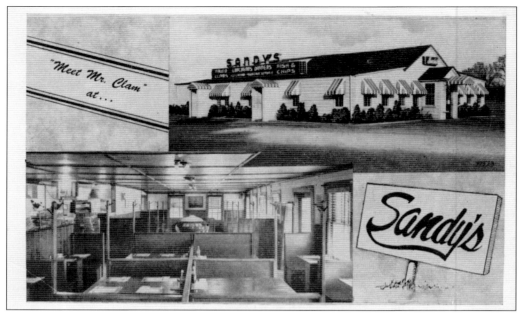

"Meet Mr. Clam" was the pronouncement on this c. 1940 postcard for Sandy's restaurant, owned by Arthur Sandstrum. It was located at 662 Belmont Street where the 7-Eleven store is today at the intersection on Belmont and West Streets. The 1951 city directory shows that there were 114 restaurants in the city; today only a few of those, such as the Cape Cod Café and George's Café, are still in business.

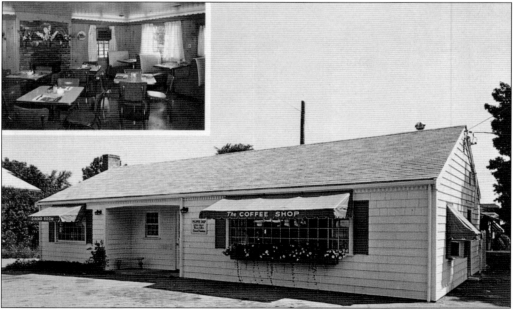

This postcard shows a quaint little restaurant called The Coffee Shop, which looks more like it belongs on Cape Cod than at 1071 North Main Street. Originally located at 821 North Main Street in the Montello section of the city, this eatery was owned by Charles Marchand, who was also the establishment's chef.

Eight

AROUND TOWN

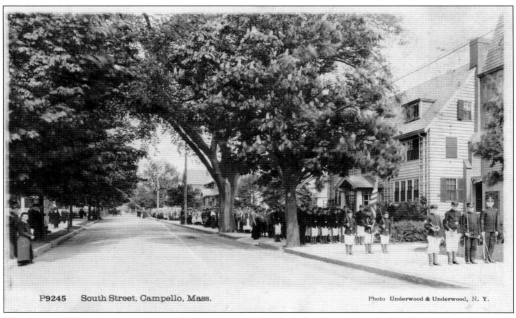

P9245 South Street, Campello, Mass. Photo Underwood & Underwood, N. Y.

The Boys' Brigade was an interdenominational Christian movement that began in Glasgow, Scotland, in 1883 and had spread worldwide by the 1890s. The group was very active in Brockton and is seen here marching down the sidewalk on South Street past its many elegant homes. This area today is the city's only registered historic district. (Courtesy of Ron Bethoney.)

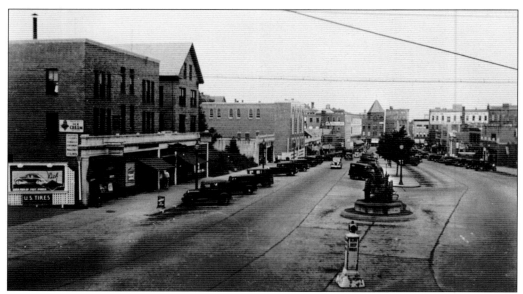

In the heart of downtown is a broad boulevard linking Main Street to Warren Avenue known as Legion Parkway. This area was created in the 1920s as a tribute to those from the city who fought and died in World War I. For many years, a large artillery piece sat at the top of the parkway in honor of those veterans. The above postcard shows the new parkway with the cannon in view as well as a traffic control kiosk. The card below depicts a later view of the space with ample parking for the many businesses that lined its way. Among familiar names of businesses that lined the parkway were the Alamo Café, Louis Benjamin Travel Agency, Gilchrist's department store, Lanoue Brothers shoe store, and many more. A memorial to all of Brockton's veterans is located today where the cannon stood. (Above, courtesy of the Brockton Historical Society Fire Museum.)

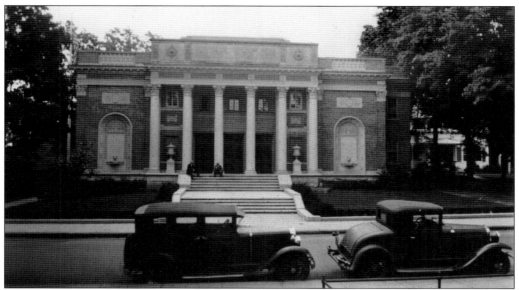

This postcard shows the War Memorial Building on West Elm Street. Designed by architect James H. Ritchie, this building was constructed in 1929, opened in 1930, and was "dedicated to those who served our country in time of war." This memorial has served as a meeting place for veterans' organizations as well as the home of the Brockton Symphony Orchestra and is the subject of an ongoing restoration project. (Courtesy of the Brockton Historical Society Fire Museum.)

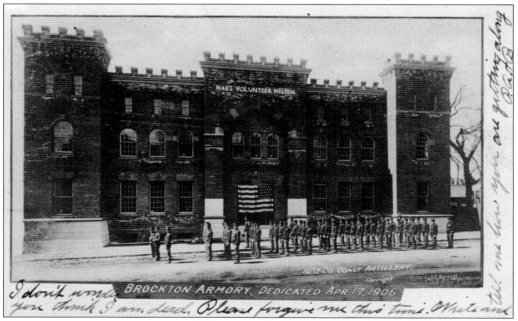

Located on Warren Avenue, this building was the home to the Massachusetts Volunteer Militia. Brockton's armory was dedicated on April 17, 1906, and it is interesting to note that, in a union publication of the time, union members around the city were urged not to attend the dedication because the program had been printed in a non-union shop. Today, this building serves as the headquarters of the local Boys and Girls Club.

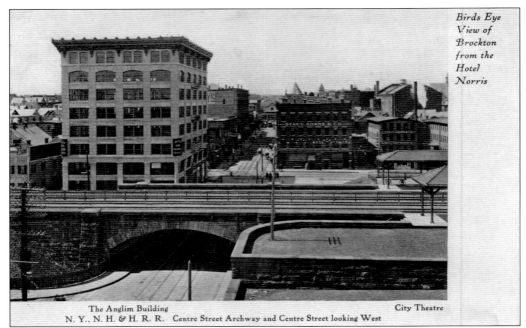

The Anglim Building City Theatre
N. Y., N. H. & H. R. R. Centre Street Archway and Centre Street looking West

The Anglim Building, pictured above, is perhaps one of Brockton's most recognizable landmarks. Designed by John Williams Beal and constructed in 1905, this yellow-brick building dominates the city skyline. Now mostly vacant, this building was one time home to the United Shoe Machinery Company as well as the Dunbar Pattern Company, and for many years, furniture retailers have occupied its first-floor space. The postcard below is a view from the Anglim Building, showing the Hotel Norris in the foreground, which was located across from the railroad station. In 1909, the hotel had 157 rooms and advertised good mattresses and white iron beds with rooms renting for $1.75 per week and up. This house was managed by George Norris, who was a noted lithographer of the day before entering the hotel business.

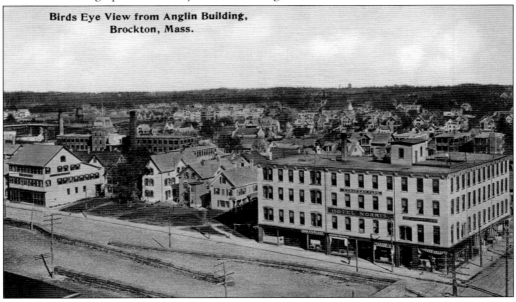

Birds Eye View from Anglin Building, Brockton, Mass.

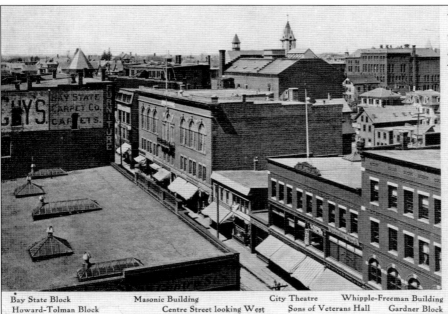

Birds Eye View of Brockton from the Anglim Building

| Bay State Block | Masonic Building | City Theatre | Whipple-Freeman Building |
| Howard-Tolman Block | Centre Street looking West | Sons of Veterans Hall | Gardner Block |

These two postcards provide the recipient with a bird's-eye view from atop the Anglim Building. In the above postcard, the view is looking upon Centre Street in the direction of Main Street. Today, these buildings are gone, and the site is being developed by Trinity Financial, a Boston development firm. When completed, the area will be a mix of retail, commercial, and residential space and will incorporate the historical identity of the past. The view below shows the east side of the railroad with the shoe factory of George Snow, the predominate building. The Snow Building is also the subject of restoration and renewal by the locally owned Brophy and Phillips Company.

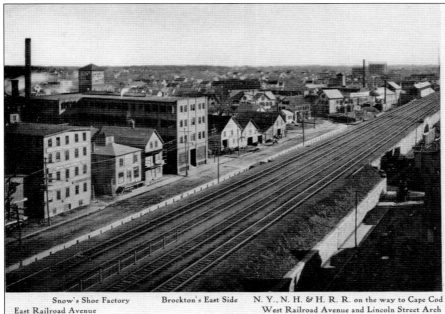

Birds Eye View of Brockton from the Anglim Building

| Snow's Shoe Factory | Brockton's East Side | N. Y., N. H. & H. R. R. on the way to Cape Cod |
| East Railroad Avenue | | West Railroad Avenue and Lincoln Street Arch |

RESIDENCE OF EX-MAYOR JOHN S. KENT, BROCKTON, MASS.

Among Brockton's most notable homes was the English Revival and shingle-style home of Francis E. "Frank" White, erected in 1891 at 375 West Elm Street. White was a shoe manufacturer in Brockton. His factory closed in 1906, and he moved to Boston. This home eventually became the home of Mayor John Kent, who was associated with the Moses A. Packard shoe company. This house was also home to Judge Harry K. Stone.

GOV. W.L. DOUGLAS RESIDENCE, BROCKTON, MASS.

With its circular tower, soaring roof, and Romanesque arches, the Wesley Lyng Minor–designed home of shoe manufacturer and Massachusetts governor William Lewis Douglas was built at 306 West Elm Street in 1891. This magnificent home, comprised of redbrick and red granite, suffered a fire, which resulted in the removal of the roof and top of the tower. This building is today a flat-roofed apartment house.

WEST ELM STREET, BROCKTON, MASS.

West Elm Street, running from downtown to West Street, was transformed in the early decades of the 20th century from a rutted, muddy road to a wide, paved street complete with paved sidewalks. Many of Brockton's industrial giants, with names like Howard, Snow, Low, Rapp, and others, built opulent residences along this roadway.

The shoe manufacturers were not the only ones in the city to have neat, well-constructed homes. This home at 27 Gifford Street even had a name according to this 1909 postcard. Arbor Villa was the home of Herman Gifford, who, in old city directories, listed his occupation as salesman. Brockton was known for its above-average wages and high level of home ownership, and this serves as a good example.

P9242 Main Street looking south Campello, Mass. Photo Underwood & Underwood, N. Y.

Stately elm trees lined the south end of Main Street in Campello before being claimed by Dutch elm disease. This view shows the home of George E. Keith on the left and that of Ziba C. Keith, Brockton's first mayor, in the distance. George E. Keith's house was designed by Wesley Lyng Minor and, though constructed of wood, contained many of the same architectural features as the Douglas house on West Elm Street. (Courtesy of the Metro-South Chamber of Commerce.)

P9243 Residence of Harold C. Keith, Campello, Mass. Photo Underwood & Underwood, N. Y.

Harold Chessman Keith, son of George E. Keith, built his home in 1910, the same year as his marriage, on Main Street near Brookside Avenue. Well-landscaped and manicured grounds belied the home's location. Keith became the president of the George E. Keith Company upon the death of his father. Today, this home is part of the Trinity Baptist Church complex.

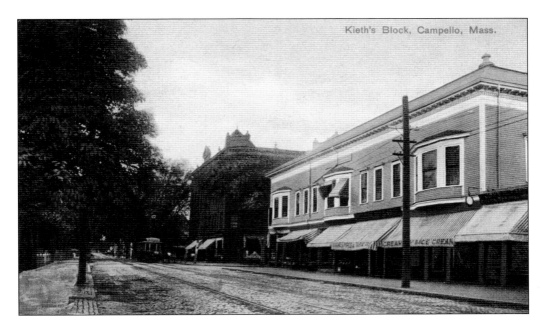

At the southeast corner of Main Street and Perkins Avenue is the Keith Block. In the above postcard, the structure seen in the background is the Franklin Building. The Keith Block had a large hall on the upper level and, in 1922 and 1923, served as the home of the First Swedish Lutheran Church while its new building was being erected. In the postcard below, the building is pictured again but without its second floor, which was lost to fire. For many years, the building was home to Ben's Five & Dime, Taft's Jewelry store, and the Campello branch of the Brockton Public Library. The building in the background was the former shoe factory of Arza B. Keith, which later housed the Carlson Brothers sheet metal shop.

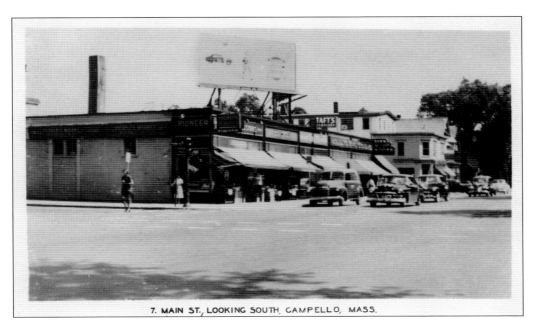

7. MAIN ST., LOOKING SOUTH, CAMPELLO, MASS.

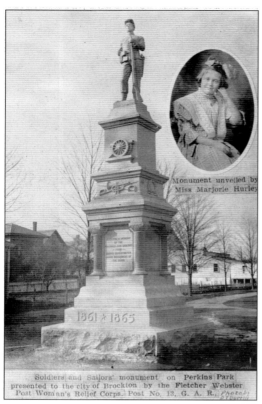

Monument unveiled by Miss Marjorie Hurley

Soldiers and Sailors' monument on Perkins Park presented to the city of Brockton by the Fletcher Webster Post Woman's Relief Corps. Post No. 13, G. A. R., *Photo by* G T Burrill

On November 12, 1907, the Fletcher Webster Post of the Grand Army of the Republic Women's Relief Corps presented this monument erected in Perkins Park on North Main Street to the city of Brockton as a memorial to those who fought in the Civil War. In the postcard at left, the inset shows Marjorie Hurley, the young lady who unveiled the statue, while the inset on the card below is the image of Fletcher Webster, for whom the GAR post was named. Webster was the son of statesman Daniel Webster and was killed at the Second Battle of Bull Run on August 30, 1862. This statue was built at a cost of $3,000 and was made of Quincy granite for the base and Westerly granite for the statue itself. It was restored through the efforts of the Metro-South Chamber of Commerce and Fred Lincoln, a former trustee of the Brockton Historical Society, with support from the community. (Below, courtesy of the Brockton Historical Society Fire Museum.)

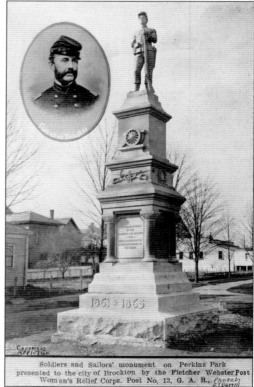

Soldiers and Sailors' monument on Perkins Park presented to the city of Brockton by the Fletcher Webster Post Woman's Relief Corps. Post No. 13, G. A. R., *Photo by* G T Burrill

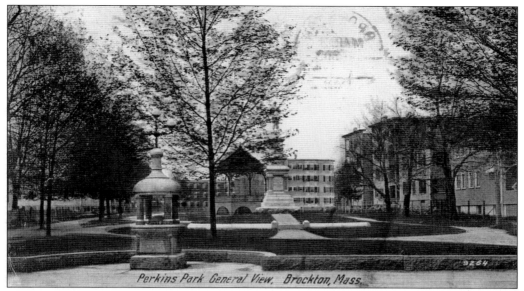

Perkins Park General View, Brockton, Mass.

These two views are of Perkins Park. The above card shows the part looking from North Main Street, while the image below shows the park looking toward North Main Street. The Civil War monument and Porter Church can be seen at the back while a bandstand is in the foreground. Tree lined and neatly kept, this park provided green space just outside of downtown and was located on what was a portion of the town's muster field in the American Revolution. In the above picture, the fountain in the foreground was erected by the Woman's Christian Temperance Union in 1894. It is thought that this park was named for Samuel C. Perkins, a soldier from North Bridgewater who was a member of the North Bridgewater Brass Band, which was attached to the 12th Massachusetts Regiment of Volunteers. This band was mustered out of service on May 8, 1862.

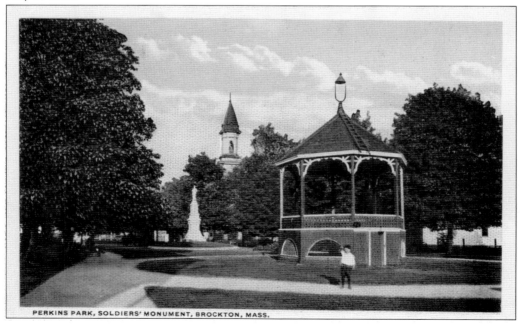

PERKINS PARK, SOLDIERS' MONUMENT, BROCKTON, MASS.

THE CHECKERTON, Brockton, Mass. Equipped with ROLL-A-WAY WINDOW SCREENS

The Checkerton and its sister, the Cheston, were apartment houses located at Belmont and Cottage Streets. Owned by Thomas Inness, these buildings were unique in design. Each apartment was constructed like a square in a checkerboard, hence the name, allowing each apartment to have three walls of windows allowing for natural light and ventilation. The Checkerton was destroyed by fire in 1983.

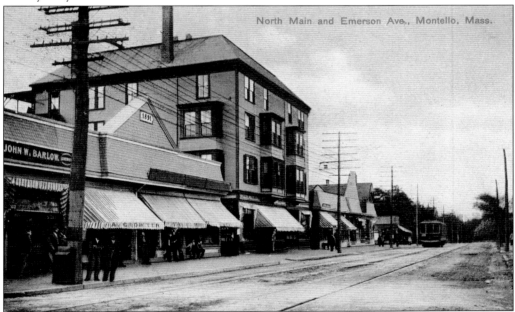

Brockton was divided into three basic centers of business—Campello to the south, downtown or Centerville, and Montello to the north. These commercial centers had their own railroad stations, post offices, libraries, fire stations, and banks. This is an early view of the Montello business district, which was the smallest of the three areas, and the surrounding area, which also was the most rural.

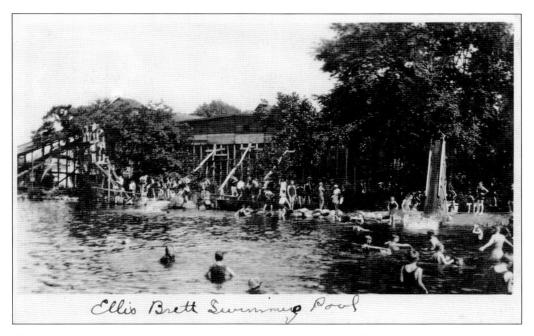

Ellis Brett Swimming Pool

These two views depict two popular swimming areas in the city. The above image shows a large crowd of bathers at Ellis Brett pond in D.W. Filed Park, while the image below shows the city pool at Montello. A similar pool existed at Campello, and both were the gift to the city by native son Edgar B. Davis. Davis was born in 1873 and for a time was engaged in the shoe industry but left Brockton to make his fortune in rubber and oil. The Edgar B. Davis School is named in his honor. Davis, having left most of his fortune earlier to charities, died in Texas in 1951 virtually penniless and intestate. These swimming areas are no longer in existence.

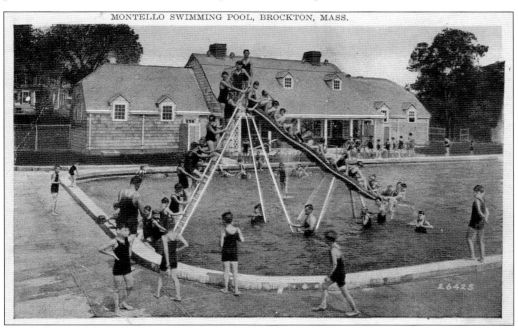

MONTELLO SWIMMING POOL, BROCKTON, MASS.

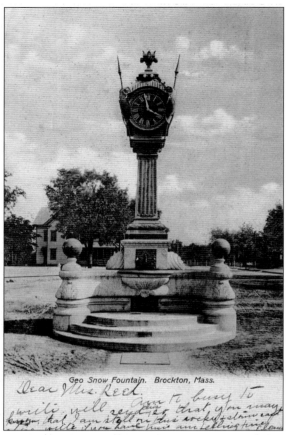

Geo Snow Fountain. Brockton, Mass.

Dear Mrs. Reed,
I write, well regards, am to busy to
hope that I am still on this rocky that you may
will have this and letting time can east

Located on North Main Street in Winthrop Square, the Snow Memorial Fountain was a gift to the city in 1902 by George C. Snow, a successful and wealthy shoe manufacturer. The fountain was the creation of the Edward Howard Clock Company and was installed by Milne and Chambers, contractors. The clock has four faces and a weight-driven mechanism. The large trough of the fountain is at a level for horses, while there is also a level for people at the base as well as a place reachable by dogs and cats. For those "cruising the drag" in the 1950s and 1960s, this was the northern turning point. Snow employed about 750 shoe workers and left much of his wealth for the benefit of the children of Brockton.

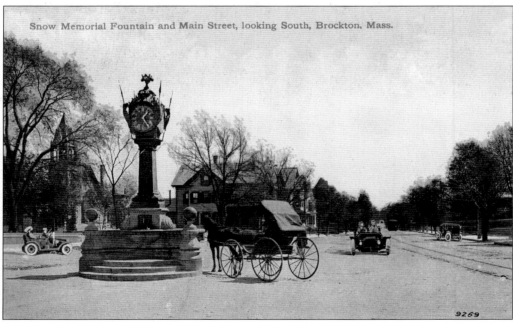

Snow Memorial Fountain and Main Street, looking South, Brockton, Mass.

9269

Melrose Cemetery on the west side of the city dates back to 1761. City owned, it is still in use today and is the final resting place of many of Brockton's most prominent business people, its wealthiest citizens, and their humble employees. The image above shows the graceful entrance to the cemetery, which is no longer used due to the size and height on many of today's vehicles. Resting within its walls are the likes of merchant James Edgar and Gov. William L. Douglas. It contains a monument to the victims of the 1905 Grover shoe factory explosion, with marked graves of many of the known victims and a mass grave for those unidentified. It also contains the remains of many of the victims of the 1928 boating disaster at Moosehead Lake in Maine. The card at right portrays the image of a proposed memorial to the veterans of the Spanish-American War that was never erected. The design was by the Long and Saunders Company, the present-day Maver Memorial Company on North Pearl Street opposite the cemetery.

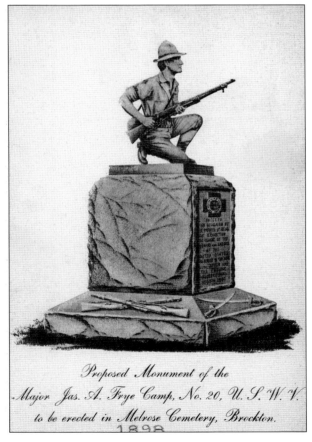

Proposed Monument of the Major Jas. A. Frye Camp, No. 20, U. S. W. V. to be erected in Melrose Cemetery, Brockton.
1898

125

THE BROCKTON
HISTORICAL SOCIETY

The Brockton Historical Society is the principal overseer of the complex of museums on Route 27. The main buildings in the regional Heritage Center consist of a fire museum, a shoe museum, and an early Brockton residence called The Homestead.

The Rocky Marciano, Edison, and Shoe Museum exhibits are presently located within The Homestead. Since its founding in 1969, the goal of the Brockton Historical Society has been to develop, encourage, and promote a general interest in and appreciation of the history of Brockton.

The organization maintains a large collection of significant artifacts and general memorabilia relating to every period of the extraordinary history of the city.

About the Metro-South Chamber of Commerce

The Metro-South Chamber of Commerce is a private, nonprofit business association based in the city of Brockton, Massachusetts. The Metro-South Chamber of Commerce supports and promotes the local business community through leadership in public advocacy, education, networking, information, and community development.

The chamber serves nearly 1,000 member businesses of all sizes from virtually all industries in the communities of Abington, Avon, Bridgewater, Brockton, Canton, East Bridgewater, Easton, Halifax, Hanover, Hanson, Holbrook, Norwell, Randolph, Rockland, Sharon, Stoughton, West Bridgewater, and Whitman.

Chartered in 1913, the Metro-South Chamber of Commerce has evolved into the region's oldest and leading economic development and business advocacy organization. The Metro-South Chamber was one of the charter members of the US Chamber of Commerce and is one of only 10 chambers of commerce in the Commonwealth of Massachusetts that is accredited by the US Chamber.

As a member of the Metro-South Chamber of Commerce, your business will be an integral part of an organization dedicated to growing area businesses. Membership is an investment in your future and the future of the Metro-South region.

Discover Thousands of Local History Books
Featuring Millions of Vintage Images

Arcadia Publishing, the leading local history publisher in the United States, is committed to making history accessible and meaningful through publishing books that celebrate and preserve the heritage of America's people and places.

Find more books like this at
www.arcadiapublishing.com

Search for your hometown history, your old stomping grounds, and even your favorite sports team.